LOTERÍA NACIONAL
PARA LA ASISTENCIA PÚBLICA

SORTEO ZODIACO No. 456

PRINCIPAL DE $ 2,000,000.00

LISTA OFICIAL DE PREMIOS

BUSQUE SU SIGNO Y COTEJE SU NÚMERO

ZODIACO

SORTEO

CONTINUA GEMINIS		CONTINUA GEMINIS		CONTINUA CANCER		CONTINUA LEO		CONTINUA LEO		CONTINUA VIRGO		CONTINUA LIBRA		CONTINUA ESCORPION		CONTINUA ESCORPION		CONTINUA SAGITARIO		CONTINUA SAGITARIO		CONTINUA CAPRICORNIO	

(Full numeric prize listing for each zodiac sign follows in densely printed columns; values predominantly $1,000.00 and $2,000.00, with highlighted prizes including:)

- GEMINIS — 3199 $10,000.00 · 3200 $20,000.00
- CANCER — 6632 $6,000.00
- LEO — 1854 $24,000.00 · 3199 $10,000.00 · 3200 $20,000.00
- VIRGO (con símbolo) — 0059 $12,000.00
- LIBRA — 3199 $10,000.00 · 3200 $20,000.00 · 3502 $4,000.00 · 3810 $20,000.00
- ESCORPION — 3199 $10,000.00 · 3200
- SAGITARIO — 6580 $16,000.00 · 2333 $6,000.00
- CAPRICORNIO — 3199 $20,000.00

Por terminación a las 4 últimas cifras del Primer Premio.

BORDE... t... between, a...

...ado... never exp...

a bea... rif... strip inhab...

hungry ghosts and fear... unveiled only in...

wicked, susurrant, bloody dream you yearn for from the wildest,

darkest corner of your desperate heart.

— BARRY GIFFORD

Bordertown

BORDE... ...on t...
sacro... ...adoo...
a bea... ...rrify...
hungry ghosts and fea...
wicked, susurrant, bloody dream you... ...wildest,
darkest corner of your desperate he...

BARRY GIFFO...

BARRY GIFFORD
DAVID PERRY

Bordertown

CHRONICLE BOOKS
SAN FRANCISCO

TEXT & DRAWINGS © 1998 by Barry Gifford
PHOTOGRAPHS © 1998 by David Perry

PRINTED IN Hong Kong
LIBRARY OF CONGRESS Cataloging-in-Publi-
cation Data available. ISBN 0–8118–1964–7

BOOK DESIGN BY Martin Venezky
DESIGN ASSISTANT Geoff Kaplan

DISTRIBUTED IN CANADA BY Raincoast
Books, 8680 Cambie Street, Vancouver, B.C. V6P 6M9

10 9 8 7 6 5 4 3 2 1

CHRONICLE BOOKS 85 Second Street, San
Francisco, California 94105

WEB SITE www.chronbooks.com

MUCHAS GRACIAS to Caroline Herter, Emily
Miller, Michael Carabetta y la pandilla at Chronicle
Books for their continued apoyo, Señor Martin Venezky
and assistant Geoff Kaplan for the diseño superior, taxi
driver Alejo Garza for the viaje especial, the ladies of
Boystown in Nuevo Laredo for the retratos, and cam-
era repairman Moisés Luján at M&M Photo in El Paso
for saving my nalgas.

Á MI ROMÁNTICA, SANTA MARIA LUISA
DE SAN FRANCISCO. Barry Gifford

PARA MI ESPOSA MARY, Y PARA OMAR
VARGAS. David Perry

La frontera del infierno

La Tribtijksjkfhjjkdjjhhjkardjdjdjdjslhfuc kkkkkkkkkkkkkkkkkkkkjjjwkwje
jjgjgjgjgjgjgjgjgjdjeijf

The Spanish invasion of what was to become Mexico began in the 16th
century. Bands of soldiers, priests and adventurers did battle with
the approximately 25,000,000 Indians there in order to claim the land
for Spain. Hernan Cortes, one of the best known of the conquistadores,
exploited divisions between Indian tribes and managed, with only a
small band of men, to conquer the Aztec empire, located in and around
what is now Mexico City. This and other conquests led to the mixing
of Spanish and indigenous blood, spawning los mestizos, the first Mex-
icans. In the border region, off spring of los mestizos became the
first Chicanos.

In the mid-19th century, the United States provoked a war with Mexico,
abd seuzed cibtrik if nycg if tge ciybtrtL kabds tgat became

In the mid-19th century, the United States provoked a war with Mexico,
and seized control of much of the country: lands that became New
Mexico, Texas, Colorado, Arizona, and California. The U.S.*Mexico bor-
der was relocated 100 miles south, from the Nueces River to the Rio
Grande. The Treaty of Guadalupe-Hidalgo, signed by Mexico and the United
States in 1848, brought with it the first border barrier, a fence that
summarily entrapped more than 100,000 Mexican citizens on the U.S.
side. Certain territory that was supposed to be property of these Mex-
icans was illegally appropriated from them, making a tragic joke out
of the treaty.

Yo tengo un pistole
Con manago de marfil
Para matar todos los gringos
Qui viennen por ferrocarril!
(I have a pistol
with a marble handle
with which to kill all the Americans
who come by railroad!)

— Folk tune popular in Chihuahua
during the Mexican revolution and the
Mexican-American war

We're going by car and on foot—

The native Texans of Mexican heritage, los tejanos, were driven from their ancestral lands by Anglos, but resistance continued. On October 18, 1915, following a train robbery by tejano rebels in Brownsville, vigilante gangs made up almost entirely of Anglos, murdered dozens of Chicanos by lynching and shooting. Thosands fled to Mexico, abandoning their properties. Since that time, big business interests in both the United States and Mexico have colluded to dispossess the poor on both sides of the border, but especially on the Mexican side. Twenty-five per cent of all Mexicans currently work in maquiladoras, factories owned by major American corporations, for barely subsistence wages. Families fall apart. There is little on the Mexican side of the border to keep the young people home. The only answer for them is to hustle in the streets or to cross the border into the United States and get something. They have nothing to lose.

The mojados cross the river, dash past border guards, climb mountains, whatever they have to do to get to the promised land. A third of them are captured by the border patrol and returned, others are robbed, raped or beaten by their own people.Most of those who make it across and manage to stay are exploited and forced to live like criminals or worse, on the border between fear and despair.

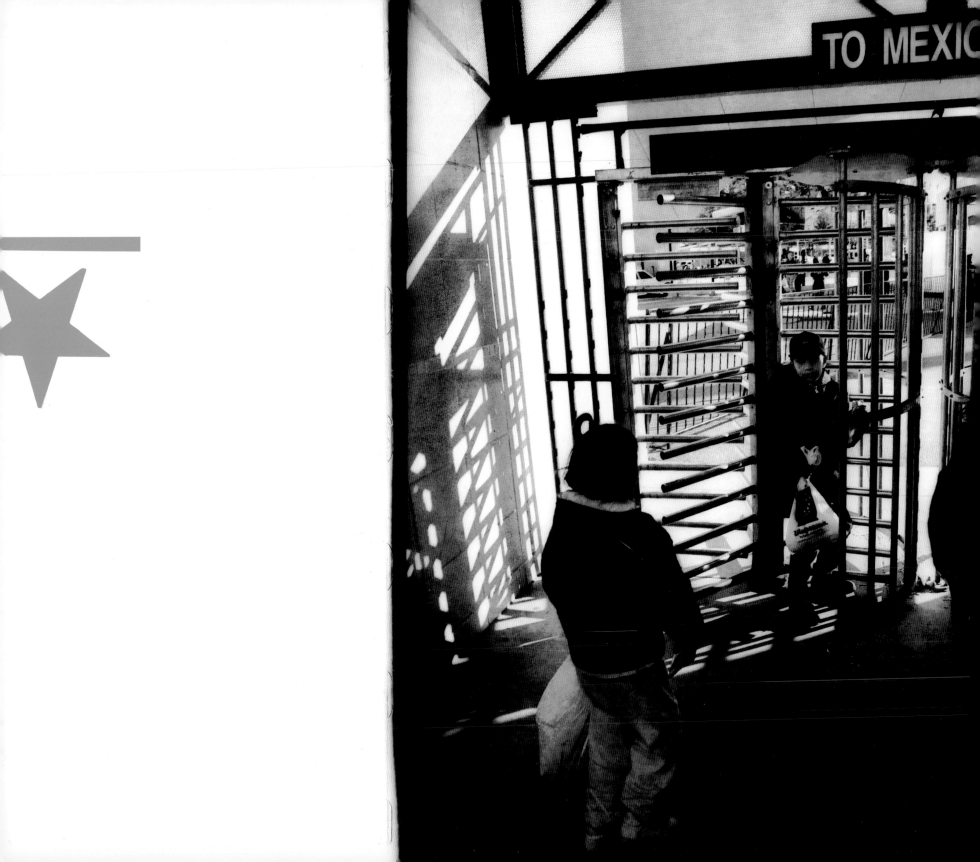

OMAR VARGAS, 3 1/2 YEAR OLD BOY, MISSING— On poster it states that he sucks the index and middle finger of his right hand. Agua Prieta looks like a bombed-out town. This has lately been the hot spot for illegals crossing the border into Douglas, Arizona. It's easy to see why—a sleepy town, a few bums in the zocalo, no tourists.

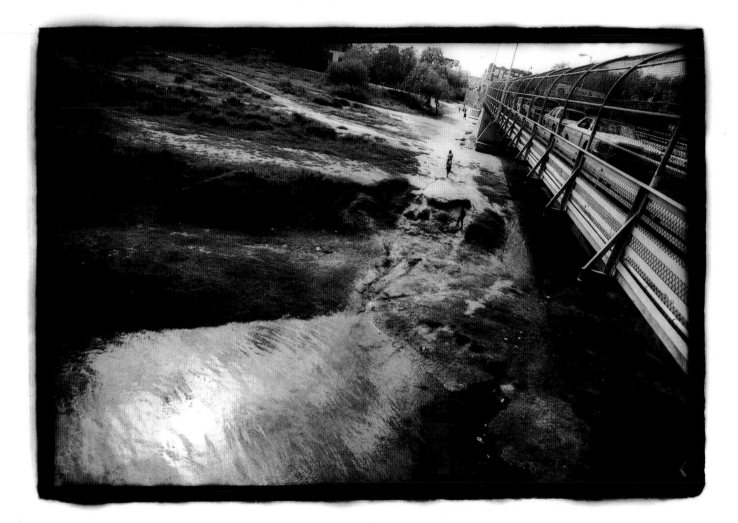

THE OBVIOUS THING about bordertowns like Agua Prieta is that they're literally stuck on the border between something and nothing. There is a furtive, almost paranoid look on people's faces. On the U.S. side, the streets of Douglas are well-paved, un-crowded, the houses mostly well-kept. Just south in Agua Prieta the bar-rios are barren, dusty roads cutting between rows of tumbledown hovels. Here and there are nice homes, the properties of attorneys and immigra-tion counselors.

When David and I were at the Oakland airport the airline clerk who punched our tickets to Tucson de-cided we looked "wrong" and had us escorted to a security room where we were ordered to empty our bags on a table. The security inspector—a woman—then took the bags and ran them through the X-ray machine. She returned them and told us to re-pack our things without ever looking at our posses-sions or examining our persons, or even my jacket pockets. She did, however, look through David's film containers one by one. Neverthe-less, it was certainly an incomplete search. When we crossed back today from Agua Prieta to Dou-glas, a female customs officer in-spected our shoulder bags. David said that the inspector in Oakland was just to prepare us for the border checks.

WHERE IS OMAR VARGAS? The thought of 3 1/2 year old Omar Vargas kidnapped in Agua Prieta sticks in my brain like a butcher knife. The other day in Belgium, 250,000 people staged a protest march against the government that had allowed a convicted child molester out of prison. I wish I knew more about little Omar's parents and how it came about that he was snatched. My children, Phoebe and Asa, both used to suck the index and middle fingers of their right hand when they were Omar's age.

SOUTHERN ARIZONA was part of the land called Gran Apacheria during the 19th century. It was the territory of the Apache nation and extended 1,000 miles into Mexico. In the Arizona Territory during the 1890s, a reward of $15,000 was offered for the capture dead or alive of the Apache Kid. The Kid (center in photo) and his gang, which included Massai (left), and Rowdy (right), were accused of multiple robberies and murders throughout the Southwest. The Kid had been

— Birthdays— -

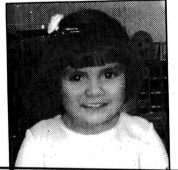

EL GÜERO Y EL PRIETO

Ronaldo Robles Ladera y Jorge Solís Martínez, de 19 y 20, años solían "chambear" en los microbuses, donde desvalijaban de sus pertenencias a los pasajeros. Su carrera delictiva se vió interrumpida, pues los amacizaron uniformados del Sector 3 Sur Cuauhtémoc.

Luz Aide Luna

Luz Aide Luna turned 3 years old October 23.

She is the daughter of Miguel Luna and Leti Nuñez of Douglas.

Her grandparents Alfredo and Ysidr and Miguel Luna an Esparza.

Her godparents a Ramirez and Villanueva.

Happy Birthday, My Little Baby!

an Indian Scout sergeant, and Rowdy was also a scout and Medal of Honor winner for the U.S. Army before they "went bad."

COMPARED TO AGUA PRIETA, Nogales is a big town. The other day two Californians were busted trying to smuggle 50 million dollars worth of heroin across the border here. The streets are a zoo of hawkers, ancient crone beggars, but the people appear more prosperous than in Agua Prieta or Douglas. Tourists flock to Nogales from all over the world to get a taste of Mexico; college kids from Tucson and Phoenix come down to get drunk and raise hell, buy dope and get laid cheap. So there's more money flowing here. The border patrol is very obvious on the U.S. side—buses loaded with illegals being transported back to Mexico pass through the border portals with regularity. But drugs is the big deal here. A magazine about narcogatilleros is devoted entirely to the drug trade, an illustrated guide to Mexico's most wanted and their victims. Published by *Alerta*, this is the *Enquirer* of drug trafficking, subscribed to by the U.S. Border Patrol.

← Probablemente la verdad Perdita Durango.

TODAY'S HISTORY: On this day in 1933, John Dillinger ... more than $75.000 fr ... National Ba ... Gr ...

SDAY, OCTOBER 20, 1936

ve Killed
Shooting in
exas Barroo

Reuters

..so, Texas

Police are searching for three ...d gunmen who en...d ... this Southwest Texas b... n and shot seven people ga... ...yle, killing five of them, p... id yesterday.

"It appears to be a pr... ...olice spokesman Bill Pfeil ... adding that investigators ...e looking into theor organized crime conn...

Two of the five who we... ...e from El Paso — ...bar own— ... a guitarist — and three ...e from New Mexico, includi... ... horse trainers. All wer... ... Saturday with lar... ...er ...pons at close rang...

Pfeil said the surviving victims, ... whom remained in the hos— ...yesterday in fair condition, ... police three armed men en— ...he bar wearing white masks ...ade everyone empty their ...kets. Then they lined them up ...shot them.

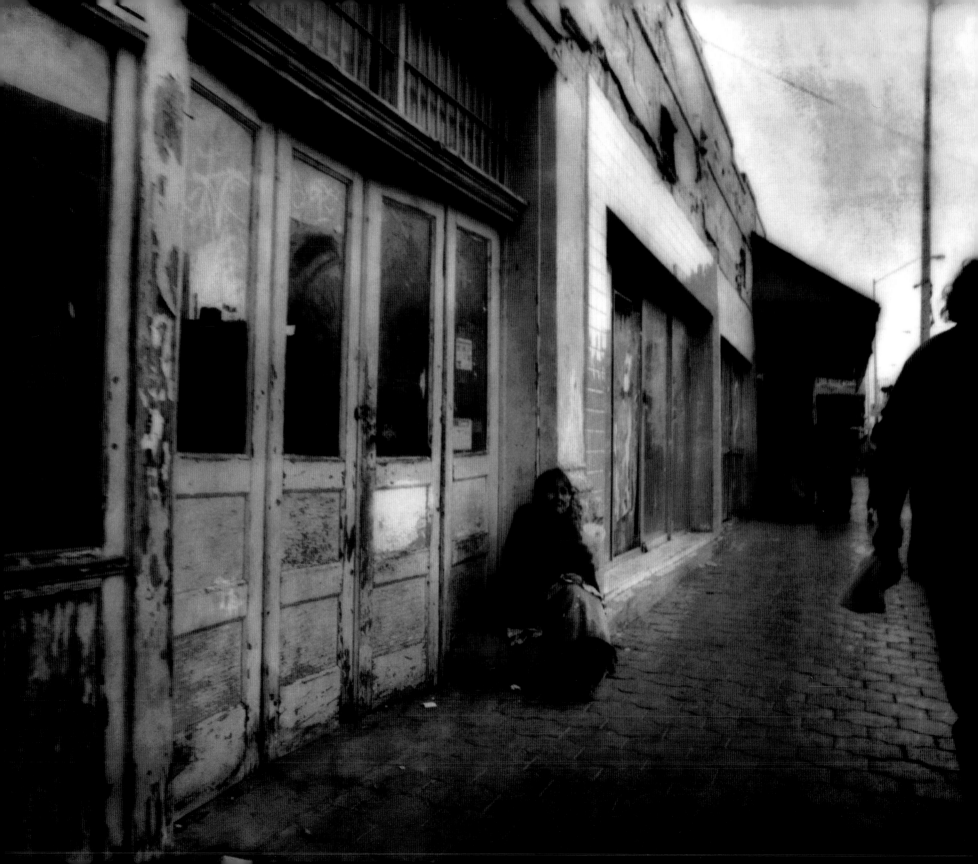

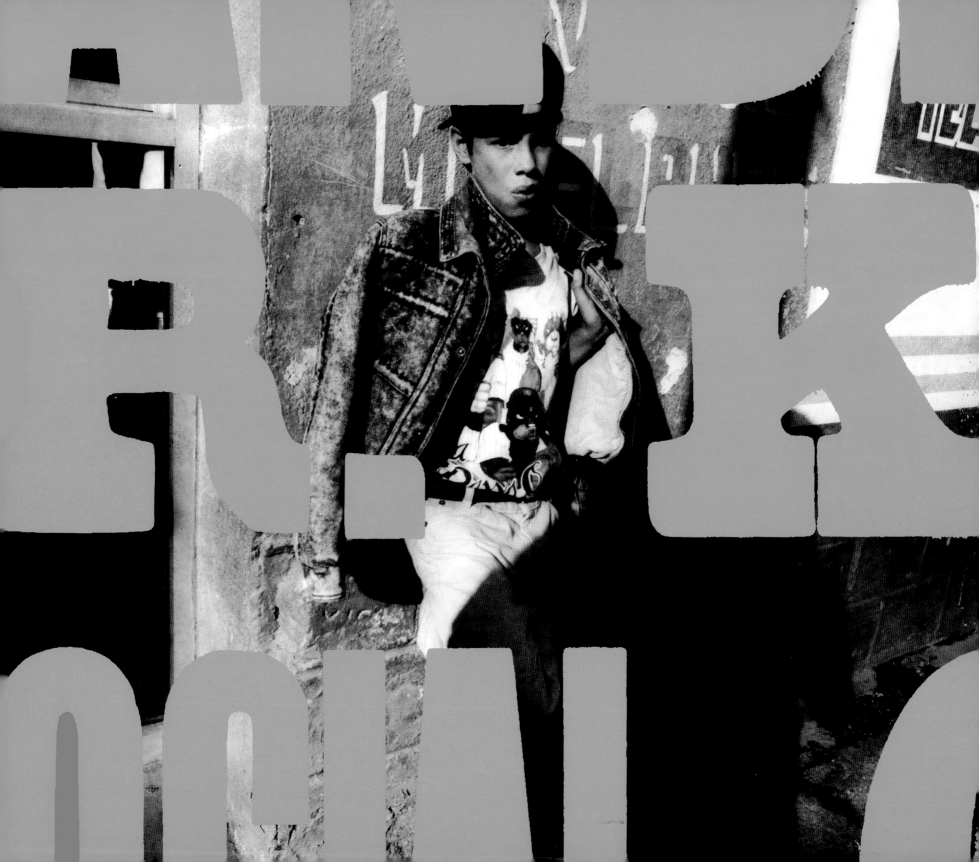

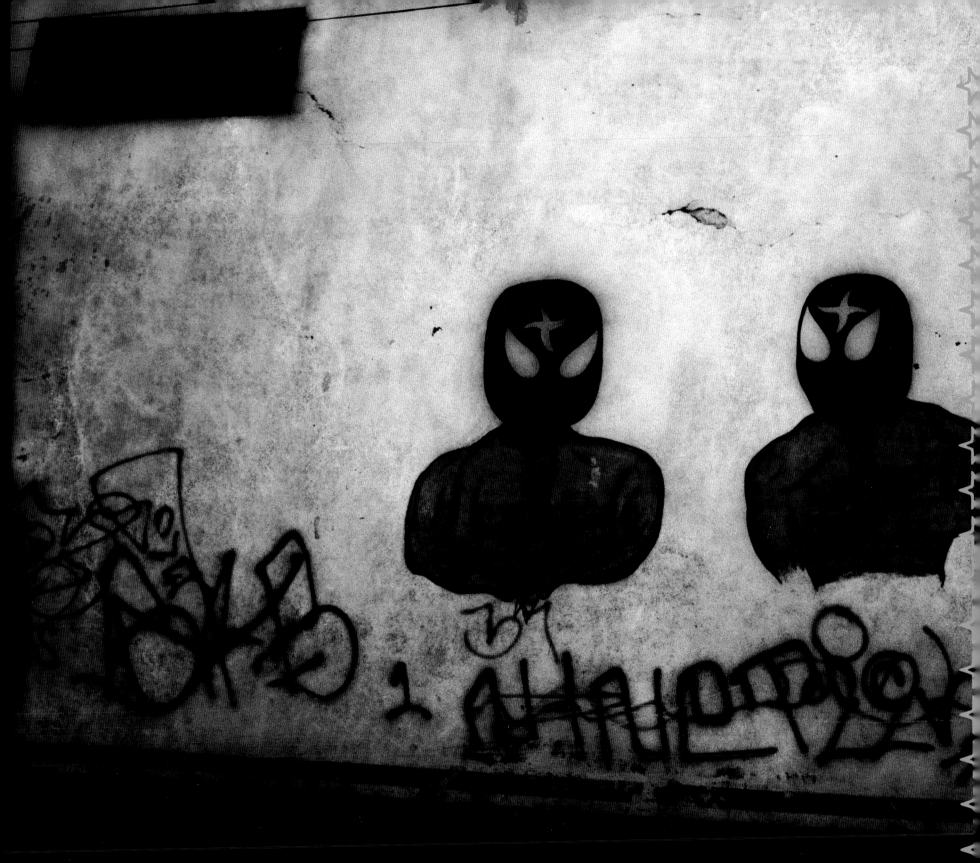

IN NOGALES, ARIZONA, just across the border, we stumble on a trailer camp out of the past—a collection of ancient Airstreams and houseboat-like portables occupied exclusively by Mexican-American families. Three border patrol cars cruise through the complex, bouncing and twisting their way over the gravel ruts. Tiny kids are running everywhere—it's almost impossible not to run them over as they dart in and out amongst the closely parked trailers. Skinny dogs snarl at the cop cars, trotting along behind them, trying to nip at the rear tires, as if they know the patrolmen are there not to protect the inhabitants but to ferret out the illegals among them. Each side of the equation has their own phalanx of satanic canines. On our way out I see a ten-year-old beauty, a Mexican girl squatting by the side of the busted road. Next to her in a faded rose flamingo chair sits the grandmother; maybe only in her forties, she looks closer to seventy. In a few years the little girl's face could sell bluejeans. I miss her already.

WE'RE IN THE DESERT southwest of Tucson where the illegals brave cactus and rattlesnakes to avoid the border patrol. I keep thinking about the kid, Omar Vargas. Who stole him and why? Surrounded by huge saguaros, the wind blowing in hard from the west, a storm coming. Clouds zoom across the late afternoon sky, the saguaros sway and bend, and the air turns cold. Maybe Omar fell into the hands of a satanic cult. I think probably he was sold to a childless couple, most likely in the United States. In the larger bordertowns, on the Mexico side, young people are occasionally waylaid for body parts, especially kidneys. But Omar Vargas was too young for that.

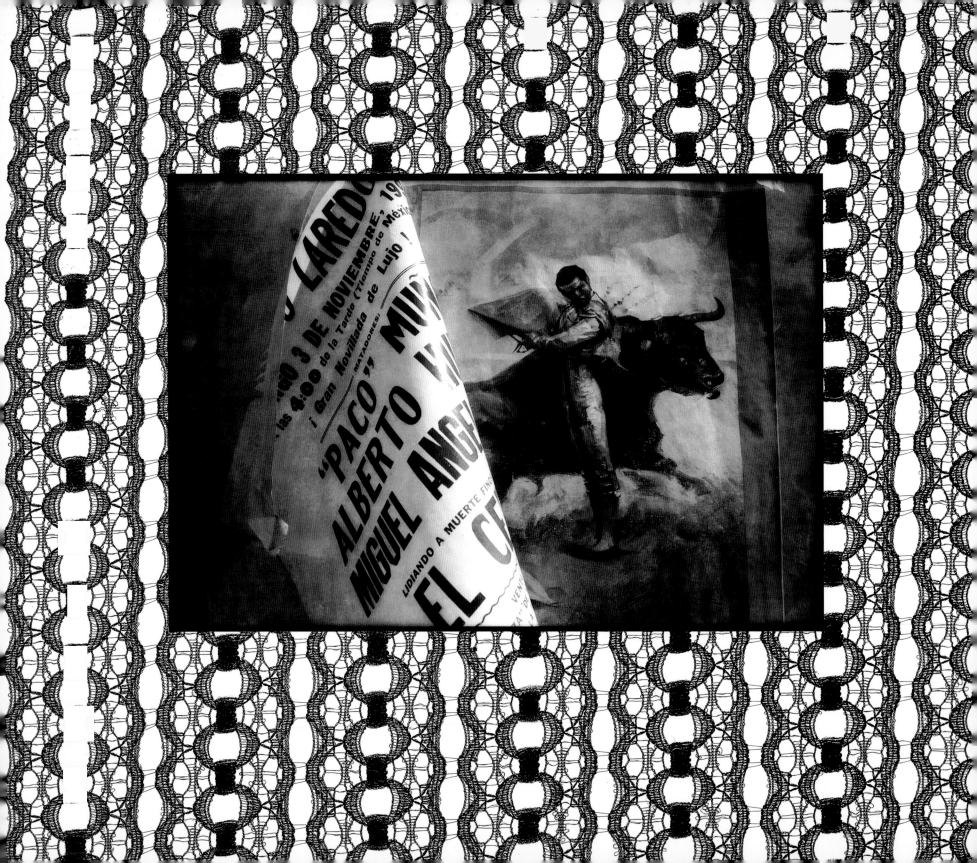

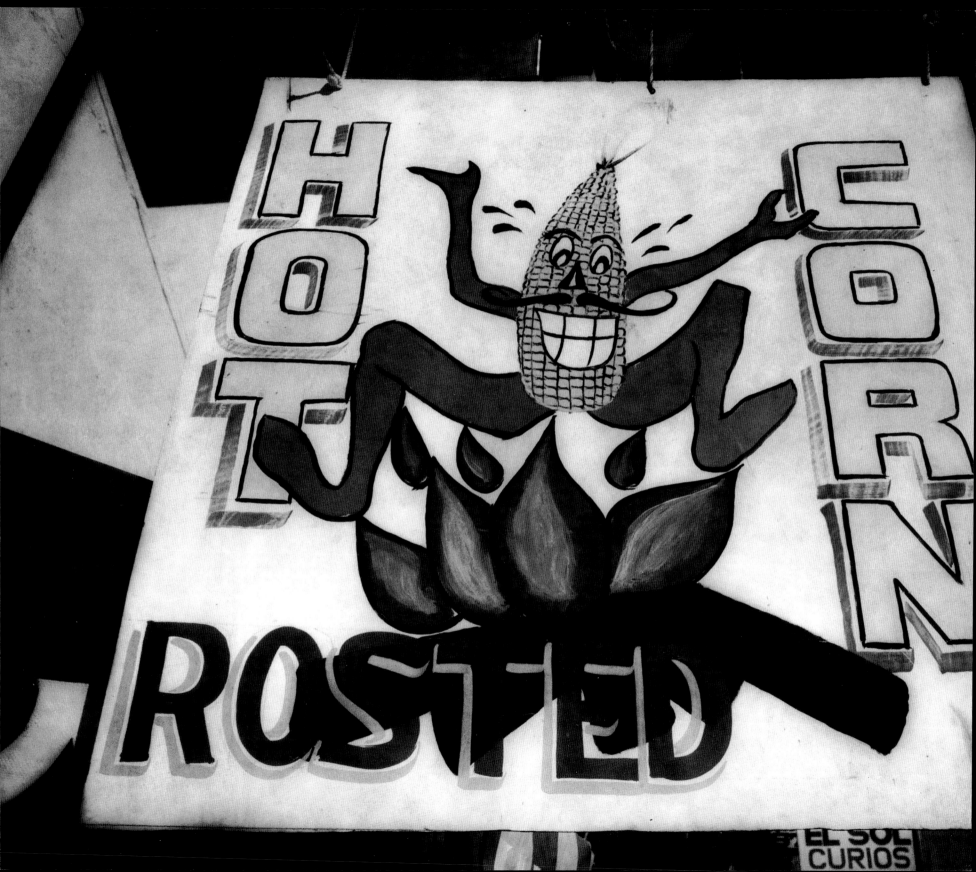

Chuy Reyes

and Esper-
anza Mar-
tinez are running
through the desert,
Chuy carrying the child. Night has
fallen hard and they're cold despite the
fact that they are sweating profusely. The boy is whimpering now,
exhausted from crying. "Mama," he squeaks. Esperanza stops and
slips to the ground.

"Come on," says Chuy, "get up. I can't carry you, too." He
keeps going. Esperanza rises slowly, reluctantly. She can hear the
little boy up ahead, crying louder now. Esperanza walks on. Chuy
and the child, Omar, are out of sight. It's dark. Chuy shouts, there's

a loud noise, someone falling, Omar screaming. Esperanza runs to-
ward the noise. She trips over a cactus, cuts her hands on the
ground. The boy is still screaming, out of control. There are several
dull, thudding sounds, all in a row, then silence.

"Chuy?" Esperanza cries. "Chuy, what happened?" She gets
up and makes her way slowly forward until she sees him standing in
thin moonlight, empty-handed.

"Chuy, where is Omar?"

Chuy kicks at a dark object, moving it toward Esperanza.

"There he is," he says. "I think he's dead."

"Oh, Chuy, no." Esperanza kneels and turns the small, broken
body so that she can see his face. "Why did you do this?" she asks.

"He was so heavy," says Chuy, "and the fuckin' kid wouldn't
shut up."

"Now what do we have?" Esperanza says. "We have nothing."

"We can always get another one. Come on,
help me make a hole."

Chuy begins to kick at the dirt
with the heel of
his right
boot.

SUNDAY MORNING NEWS ITEMS: In Douglas, the day we were there, Jimmy Rodriguez, quarterback of the Douglas Bulldogs high school football team, died of a self-inflicted gunshot wound. Yesterday, his team dedicated their game against Santa Rita, another bordertown school, to Rodriguez. They won, 28–0. Jimmy's funeral also was yesterday. He was buried at High Hope Cemetery in Douglas.

THE BORDERTOWN BEACH for Arizona is Puerto Peñasco, called Rocky Point by Anglos. It's a four-hour drive from Tucson by way of Sells, Quijotoa, Why, Lukeville, and Sonoyta, through the Tohono O'odham Indian reservation. Mexico's Highway 8 takes you straight to the Sea of Cortez. The *Arizona Daily Star* reports that the biggest problem with Americans in Puerto Peñasco is that they drink and drive. One of the prime sources of local income is fines for drunk driving.

IN SIERRA VISTA, just north of Douglas, an ex-con abducted a car salesman during a test drive and tried to go to Pennsylvania to see his mother. The salesman managed to escape when they stopped at a coffee shop in Socorro, New Mexico, around midnight. The salesman threw hot coffee at his abductor and fled the restaurant. The kidnapper was arrested later when he showed up at a hospital to get treatment for burns from the hot coffee. The victim happened to be at the same hospital for a check-up and spotted the guy who abducted him. The thief had just finished serving a five-year prison term for stealing a vehicle from another car dealership in Sierra Vista. He went berserk when arrested and declared that he wanted to kill all the people at the Arizona State Prison in Florence who had mistreated him. The miscreant used a knife during the recent episode and told the car salesman that he was going to buy an assault rifle in Texas, then visit his mother one last time.

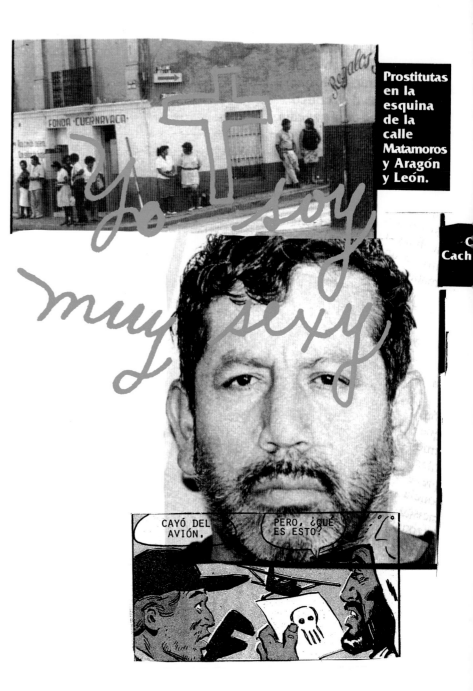

LAST NIGHT HECTOR FELIX, of Tucson, a 23-year-old man, was shot dead and two other men were wounded outside "The Krew" Club on the south side of town. No witnesses to the shooting could be found, but neighbors reported hearing gun shots, screaming and vehicles speeding away from the scene around 2:30 a.m., said Sgt. Eugene Mejia.

AT THE SILVER SADDLE MOTEL, a man named William Felice was shot and killed by the motel manager after Felice broke the manager's window with a shovel and yelled threats to him. The motel manager shot Felice with a small caliber pistol after which the wounded man staggered along Flores Street, where he eventually collapsed and died.

lebro (a) "El
il dólare

Lino Hurtado quedó convertido en una masa sanguinolienta.

Jorge García Vargas fue otra de las víctimas de los homicidas a sueldo.

ca imaginó q... una mujer casada perdería la vida.

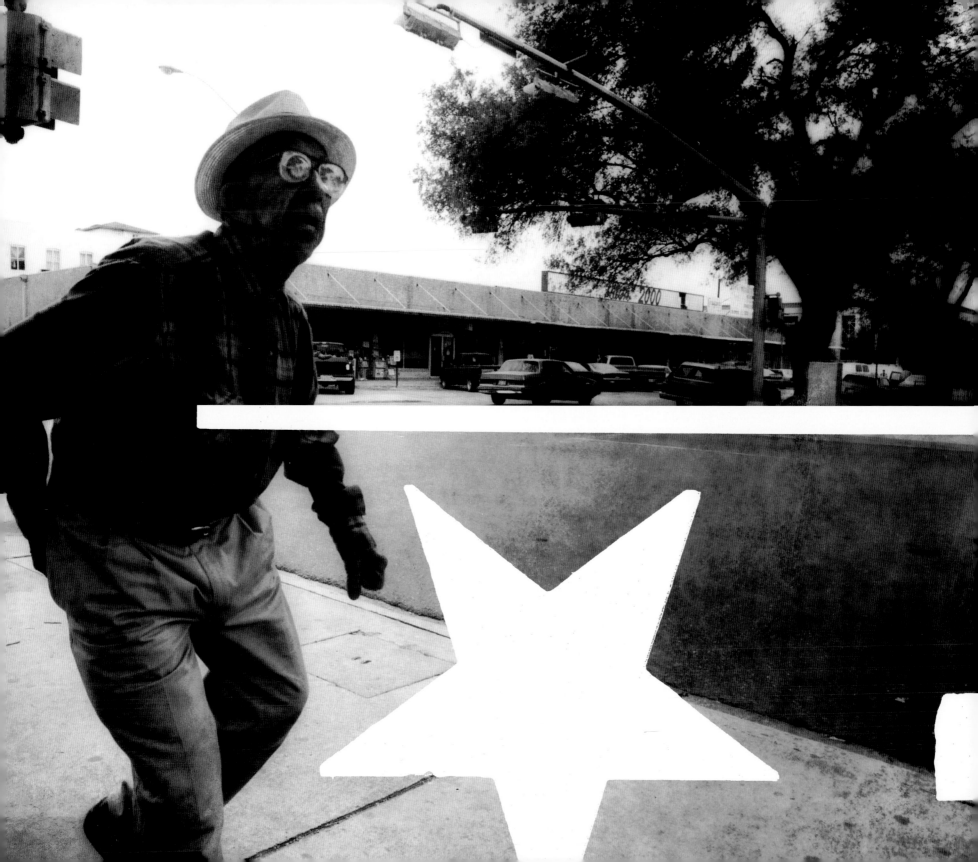

JUST NORTH OF NOGALES, condominium and housing developments, with the residences built around golf courses, are being constructed like crazy. It's a horrifying sight to see this blight upon the oth-

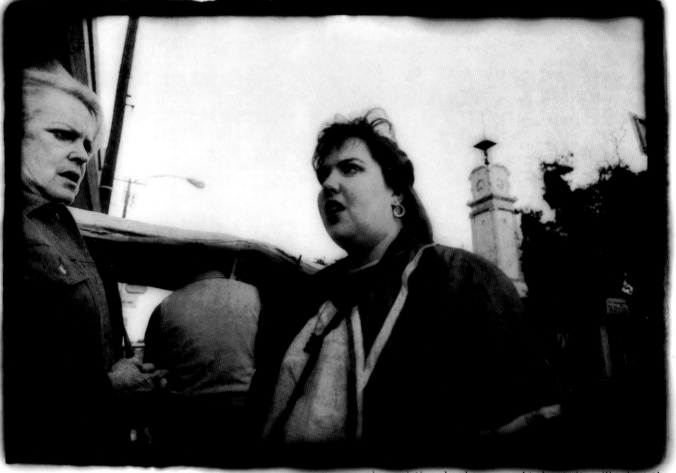

erwise pristine landscape. At least it will give the illegals running through the area some refrigerators to raid when the residents are out on the golf course.

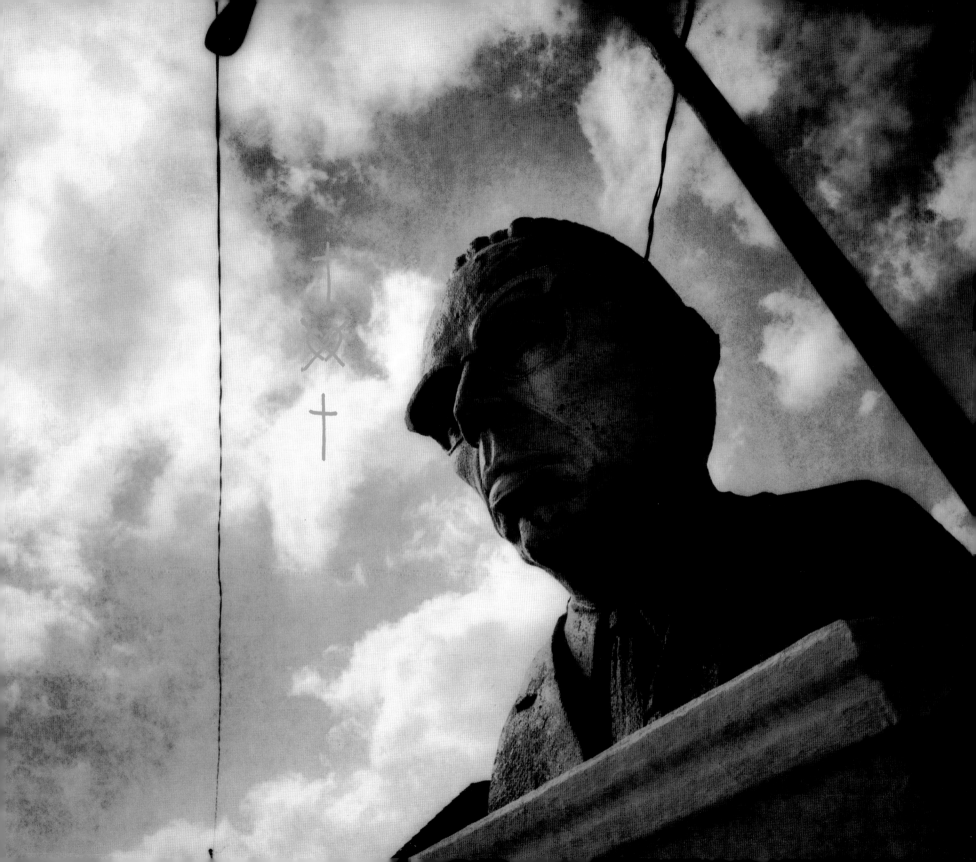

Cookie

Cruz met Tico Mariposa on the Santa Fe bridge between El Paso and Juárez. She was returning from her job at the Camino Real Hotel, where she worked as a maid. Cookie lived with her mother, Rosa, in Juárez, despite the fact that she possessed a green card and could have lived in the U.S.A. Tico was born and raised in El Paso. He worked on and off as a groom at Sunland and Juárez racetracks, but had fallen in with a bad crowd that hung out at the Club Colorada in Juárez. He became a crack dealer and user. Tico was a handsome boy of twenty-two when he hit on Cookie, who

was a year younger. They walked together into Mexico and that
was the last anyone in El Paso ever saw of her. Tico Mariposa
took Cookie Cruz with him to his room above the Buena Suerte bar
on the corner of Avenue 16 de Septiembre and Pancho Villa. She
was tired after working all day and not eager to make dinner for
her mother and herself, so Cookie took a hit when Tico offered her
one. She passed out at some point and when she woke up Tico
was raping her. Cookie screamed so Tico popped her in the chops
with his right fist, then smack on the nose with his left. She was
bleeding and crying when Tico turned her over and tried to stick it
in her ass. Cookie crawled forward, grabbed a small lamp without
a shade and raked it backwards across Tico's face, shattering the
bulb. He released her and Cookie jumped up. She was too dizzy
from the drug to stand. Cookie fell over and looked at Tico. He
was lying on his left side with pieces of the light bulb sticking
out of his right eye. Cookie couldn't move from the corner where
she had fallen. Her face was streaked with blood and tears.
She wanted to close her eyes but they were frozen open. Tico
rose to his knees and slowly picked the pieces of glass out of his
face. He reached down and picked up a gun and pointed it at
Cookie Cruz. She thought about Rose, her mother, waiting for her
in the little yellow house on Calle Mejia, the house her mother
would never leave. Cookie had fantasized since she was fifteen
about going to Nueva York and sitting in the sun on the edge of the
fountain in front of the Plaza Hotel, which
she'd
seen a photograph of in a magazine. Cookie imagined herself
standing naked in the Plaza fountain under a warm sun,
and she smiled, her eyes
closed, as Tico pulled the
trigger.

Heroin bust: A passenger in a taxi was in federal custody Monday after customs agents at the Bridge of the Americas found black-tar heroin with an estimated value of $470,600 hidden in his shoes, an Immigration and Naturalization Service spokesman said.

The unidentified man — who had hired the cab at the Juárez airport — appeared nervous at primary inspection, where he had declared only a small bag of clothing, spokesman Dan Kane said. The 517-gram stash of Mexican heroin was found in a secondary inspection. Other information about the case wasn't available.

Police seize marijuana

CIUDAD JUAREZ — Police on Sunday seized 150 pounds of marijuana from two Cuauhtemoc, Mexico, men who tried to avoid a highway drug checkpoint.

Zoilo Chavez Garcia, 25, and Jorge Rios Galeana, 25, were carrying the drug in plastic bundles in a pickup on a dirt road leading from Villa Ahumada to Juarez.

POLICÍAS GRINGOS

CÓMPLICES DE NARCOS

Sexual abuse suit: Two Guatemalan citizens who now live in California have filed a federal lawsuit against two unnamed U.S. Border Patrol agents from El Paso for allegedly sexually assaulting them in March, according to court records. They're asking for $5 million each in damages.

The women are being represented by lawyer Tony Silva. Silva was unavailable for comment. U.S. Border Patrol spokesman Doug Mosier said the incidents are under investigation by the U.S. Inspector General's office and that the agents accused in the lawsuit have been placed in a non-law enforcement position.

San

ue M
su

s para cuida

ANDIA - MÚSICA

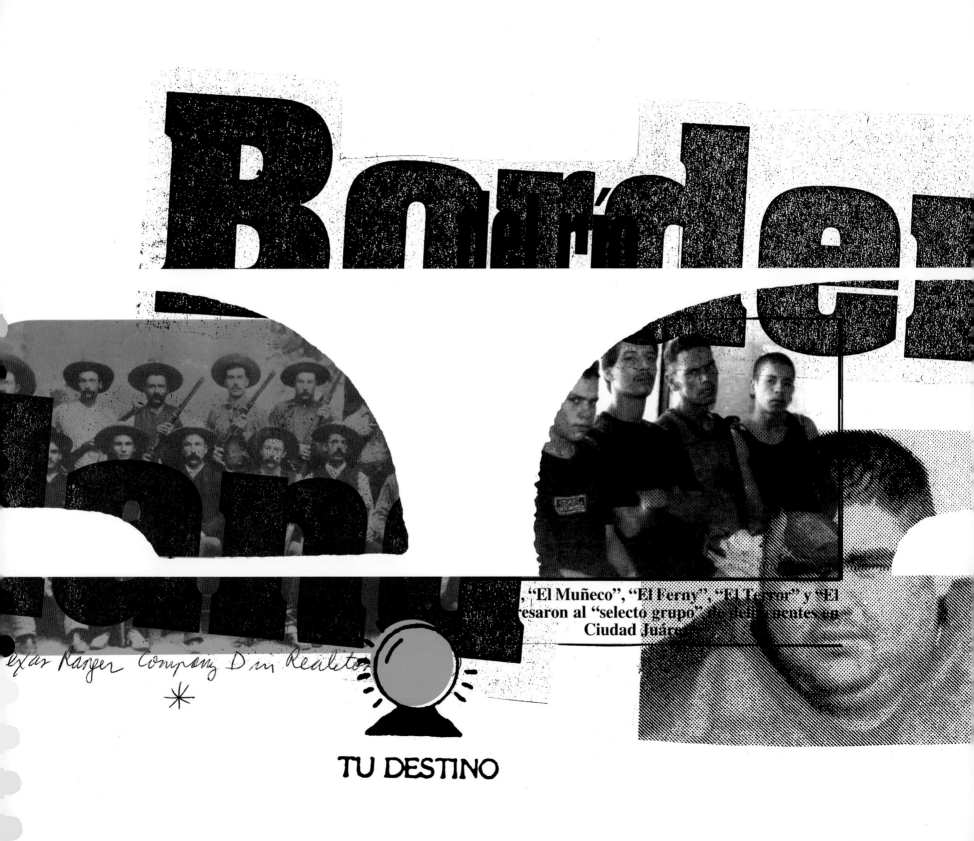

"El Muñeco", "El Ferny", "El Terror" y "El
esaron al "selecto grupo" de delincuentes en
Ciudad Juáre

TU DESTINO

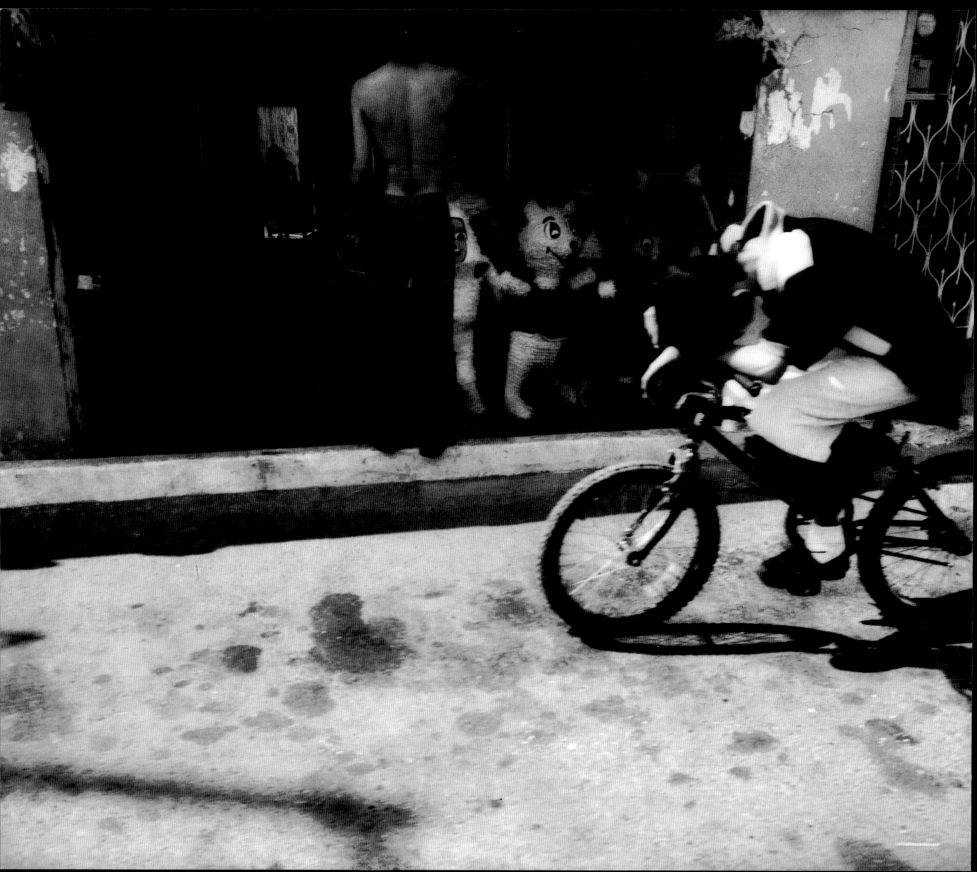

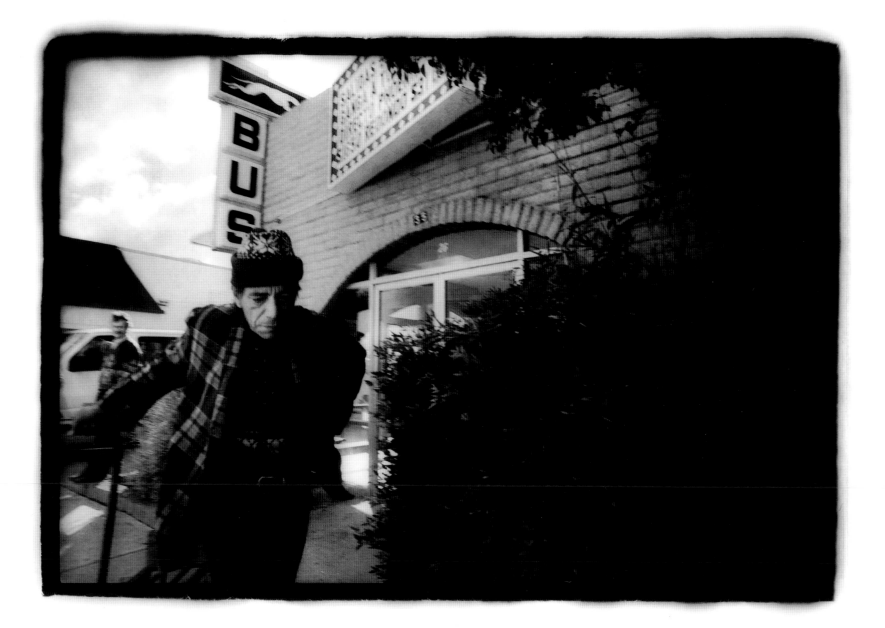

vision del Calle CruzReу

"*La*"

Old guy
sitting in his
yard

yard
in Caseta
under the only
tree
reading
Dostoevsky's

Los Diablos

skinny dog
circling
him slowly

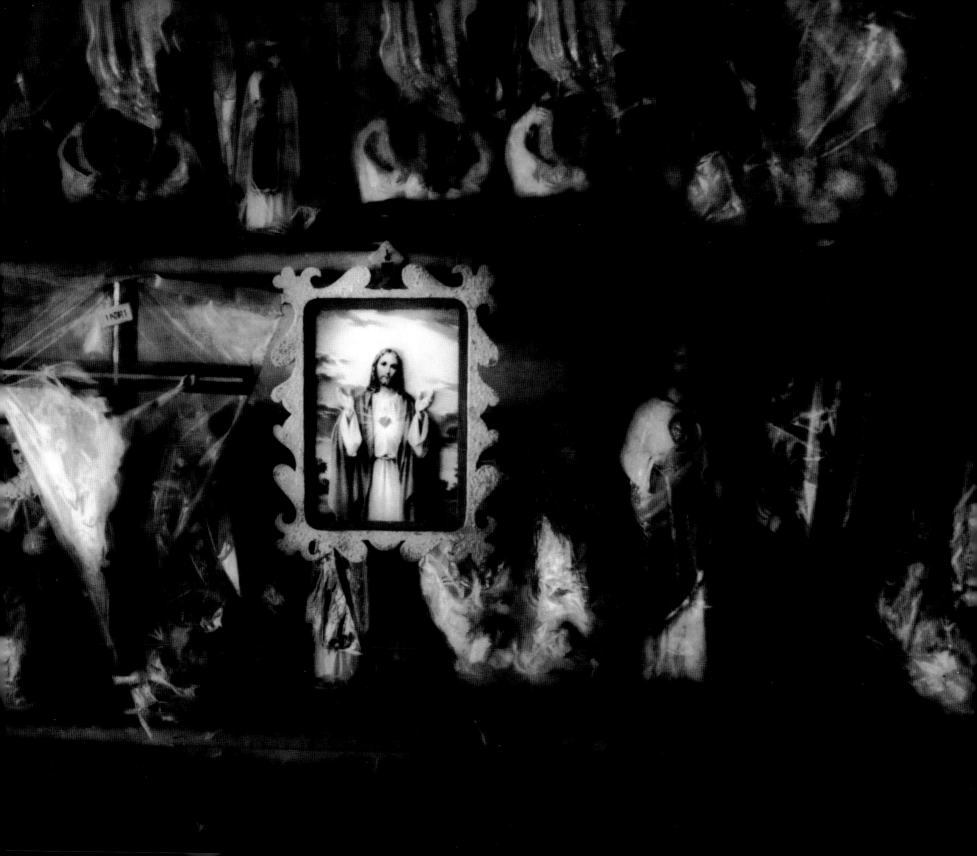

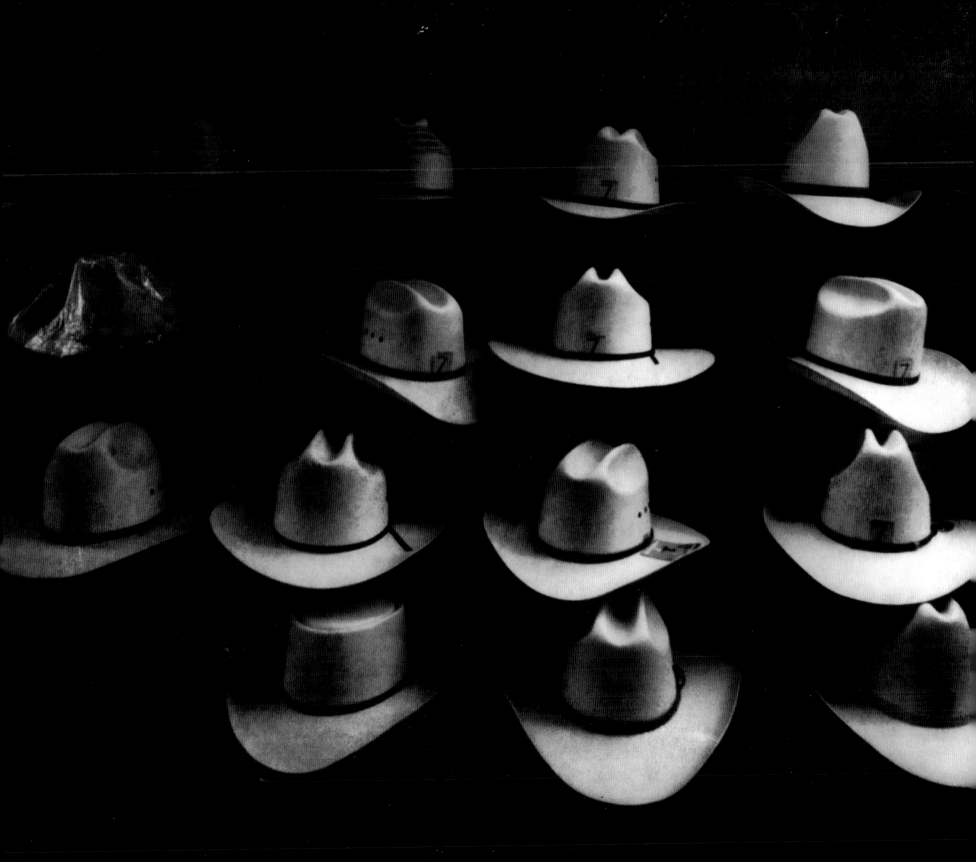

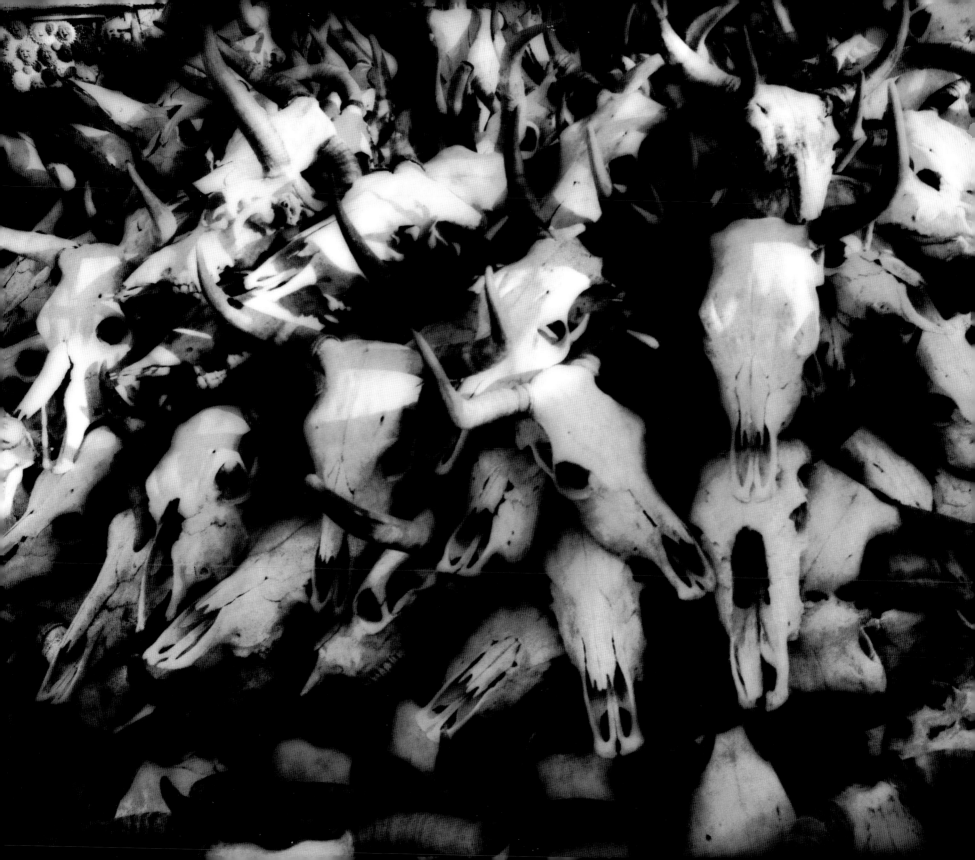

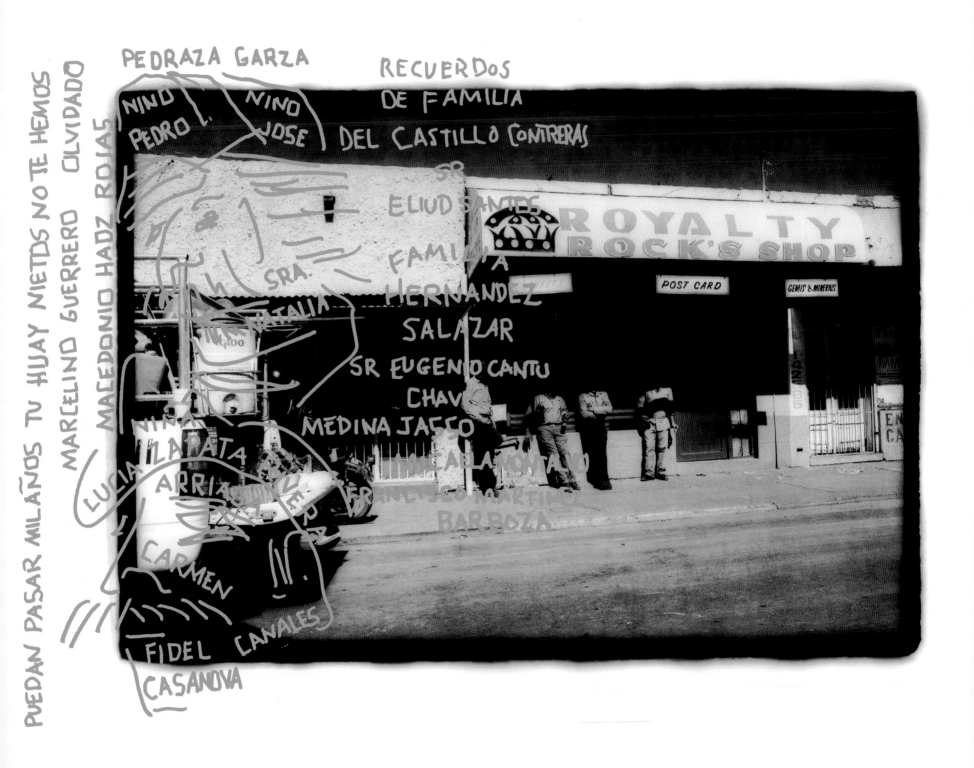

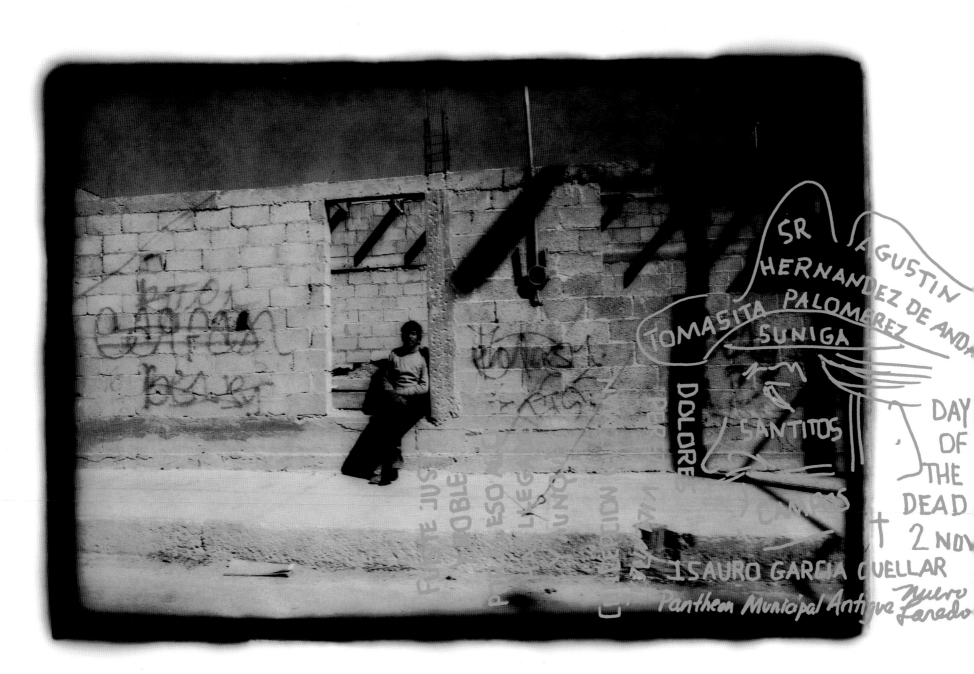

SR AGUSTIN
HERNANDEZ DE ANDA
TOMASITA PALOMEREZ
SUNIGA
DOLORES
SANTITOS

DAY
OF
THE
DEAD
2 NOV

ISAURO GARCIA CUELLAR
Pantheon Municipal Antigue Nuevo Laredo

God can help us overcom

our evil ways

Why do we never seem to learn from the mistakes of others, or from our own mistakes? The reason, the Bible says, is because human nature has a natural inclination toward evil — and away from God. We are prideful and do not like to admit that, but it is still true. As the Bible says, "The heart is deceitful above all things . . ." (Jeremiah 17:9).

Girl at Club
Tamyko
BOYSTOWN
Nuevo Laredo

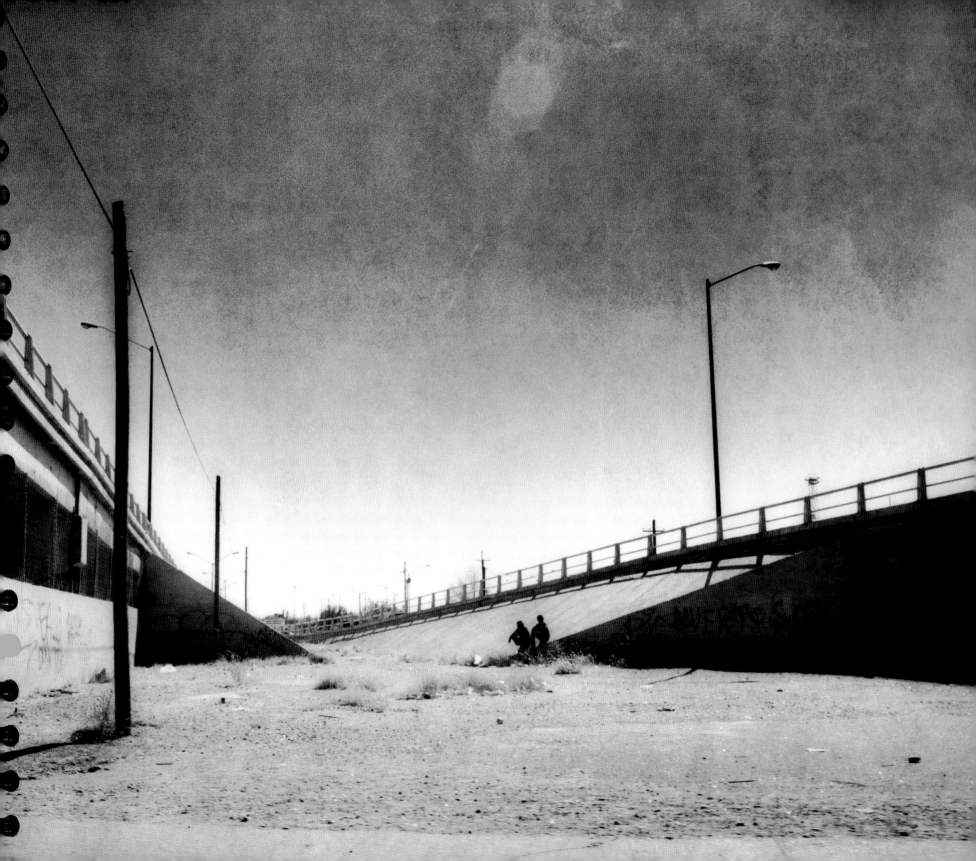

a, Mexico

ster Natividad speaks softly carries a big stick.

Angered by the kidnapping of a 10-year-old girl, the mother superior of a Reynosa convent on grabbed a stick and marc the notorious red-lig known as "Boys T

Confront who gua ighborhood, Sister Natividad — who barely reaches five feet tall — threatened to strike anyone blocking her path.

Grudgingly allowed to pass, the nun began looking in the dozens of strip joints lining the neighborhood's streets. Sister Natividad finally found the young girl in a cramped room, bound and gagged.

"I thought I had walked into hell," the 56-year-old nun said in a recent interview. "Everyone looked like little devils. It was horrible."

Fearing the wrath of a nun, the kidnappers quickly freed the girl, er Natividad said was des- sale into prostitution.

ay of the Dead

RICK HUNTER/staff

woman sits in the pre-dawn light at her
sband's gravesite after an all-night
dlelight vigil marking Day of the

I Want To Be A Star

Name _____

Address _____

City _____

State _____ Zip _____

Day Phone _____

Eve Phone _____

Mail To: Express-News "Make A Scene
 c/o KTFM 102.7
 P.O. Box 18323
 San Antonio, TX 78218

Or Drop By: KTFM 102.7
 4050 Eisenhaur Rd.
 San Antonio, TX 78218

Selena

RAMON IRUEGAS

Want to make it big on the silver screen? Well, the
Express-News is giving you a chance to play a role in
the movie *Selena*. If you're our lucky winner, you and
a guest will be treated like real stars. We'll fly you to
Corpus Christi for the filming. Outfit you in a glitzy
wardrobe for the scene. And give you accommoda-
tions at the Residence Inn by Marriott, transportation
by Limousines Unlimited of Corpus Christi and a gift
certificate to the Selena Boutique.

Ramon Ir

Ramon Ir
away Friday

Pallbearers
Juan Iruega
Beto Iruegas
Manuel Gor
Iruegas.

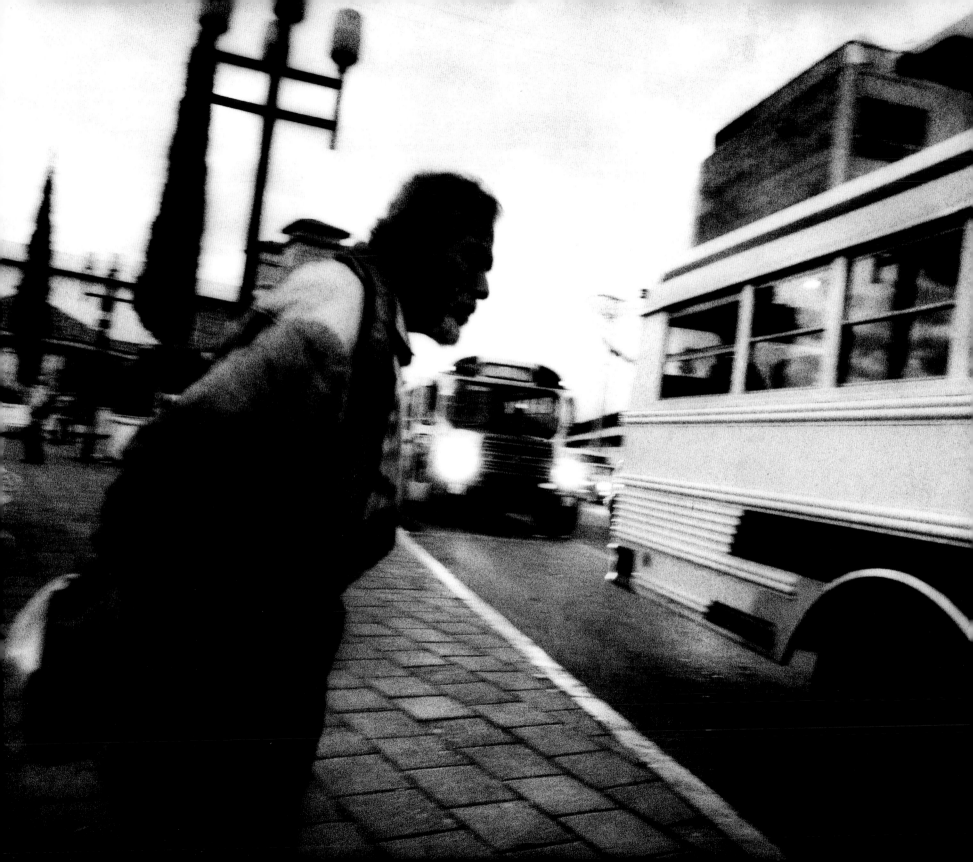

ARRIVING AT BOYSTOWN in Nuevo
Laredo—a complex of whorehouses, bodies and faces for
every taste. The most beautiful chicas are at Club
Tamyko, Club Papagayo and Club Marabu, which has
the palatial grounds. The complex is surrounded by
a stone wall plastered with political advertisements.
The Club Miramar is all boys for boys—transvestites,
many more beautiful and alluring than the "real" girls.
Next door to the Club Tamyko—which has a Japanese
motif—is the donkey show. Boystown is the Disney-
land of Love. One of the whores, a pretty redhead
named Lola, gave me a red plastic flower she said was
from the grave of her mother, which she visited today.
She said to remember her. Un recuerdo de una chica
perdida.

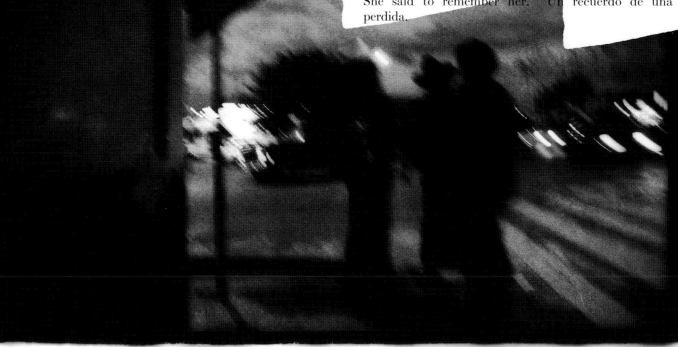

The first

21 NOVEMBER
NUEVO LAREDO

MI CORAZÓN,

thing a girl like me does, or should anyway, in a place such as Jalisco,

is find a man. This statement may seem uncharacteristic considering the source, however let me explain. First of all a man can drive you around, buy you things, and most importantly, dissuade all the others. If a girl like me doesn't get hooked up with some kind of male and quick, she'll end up with everyone including the village faggot chasing her skirt which is what happened to me and I'll tell you a thing like that can really ruin a girl's holiday.

After two days in the big city, Lucha and I headed
out for Tecalitlán, which is about 40 miles away from Guadalajara.
If you have heard of "Teca" it is because that is where Mariachi
Vargas (the most famous mariachi) is from. Tecalitlán is a pueblito
of about only this many people. We stayed with Doña Celia who is
about 75, 250 pounds, allegedly a witch, and one of my favorite
people. She claims she is not going to die until she gets her first
born son married to Lucha. So we are in pretty deep with Doña
Celia and the rest of the neblinas. Doña Celia has about this many
kids and that many grandchildren so the house was always over-
flowing and I love that sort of thing as long as it is temporary. Un-
fortunately all of her children did not inherit her intelligence. For
example, she has one daughter whose husband has another woman
who he cannot leave because in order to get him she went to see a
brujo who told her to put shit and menstrual blood in his food and
the son of a bitch ate it. Now he's even got his stupid wife feeling
sorry for him because he ate the disgusting concoction and because
of the spell he is allegedly under. Can you believe that shit? Crazy.
My boyfriend for the week lived across the street.
Paco, a young man who comes from a long line of drug traffickers
and politicians, pretty much the same thing. The fiestas were a lot
of fun. It is quite a convenience to walk up the street, get drunk
and dance all night, then walk home. The castillos, elaborate
frameworks to set off fireworks, are set off right in front of a
dried-up cornfield adjacent to the church, which is pretty crazy be-
cause there is no fire department in the town. It's pretty danger-
ous and people frequently catch on fire. One macho got hit and his
shirt got scorched so all the people laughed and cheered.
Everyday I would have about half a dozen people

"calling" on me, just like in them British novels. Then they take
you to their patios by the arm to "platicar" or chat. I got adopted
by about ten different families which is more than it might seem
since so many people in these little towns are from the same fam-
ily. You understand? Anyway, speaking of families, the thing I for-
got to tell you about was the fact that Paco's little sister Maria,
who I absolutely adore, married her uncle. Seriously, her father's
brother. I know that probably doesn't surprise you, but it did me
after I found out about it after I hung out with her all week. Not
that a thing like that turns me against a person, it just makes you
wonder. And this girl is beautiful. That side of the family is from
Michoacan and if one believes what Lucha says, there's nothing
but mala gente in Michoacan. My great grandfather was from
"Michigan" which is what you call it if you're cool, and he was a
bad bad man. He died of poisoning by a woman and from the sound
of things, he got what he deserved.
 We drove down to Colíma which was pretty boring
except for this one stretch of road. You drive up a hill then down
into a valley. It's really steamy and foggy but hot and there are
nothing but coconut trees on either side of the road with banana
trees growing in between them. It was the strangest place. If the
devil had a resting place I think that was it. I mean I don't think
he conducted any business from there or anything like that, it was
just a place to go and rest, if the devil does such a thing. They
say he don't.
 One afternoon I was sitting in the street talking to
a bunch of people. Imagine me with bobbed hair, tattoos, a long
flowing black lace dress, and lipstick, sitting in the street in this
town. Then all of a sudden everyone is yelling at me and the bells

are ringing. It seems every day at such and such an hour you
have to stand facing the direction of the cathedral and cross your-
self and say a little prayer for the benediction. I guess it's the
sort of thing that keeps the church from burning down when they
set off the castillo in front of the cornfield.

We spent our final night there with a bunch of
mariachis. They took us for all our money because Lucha fell for
one of them. We got very drunk and sang with them, which is our
favorite thing to do. Tonight Paco is supposed to call me. I think
I'll make him sing to me. I'm going to go back to see him in two
weeks. Fiesta time in Teca is from the eighth through the thir-
teenth. The 12th is the Dia del Guadalupe, which is incredible, or
so I'm told.

Very soon it will be Christmas, of course. Maybe
you will send me money for a new dress. Sometimes I think I
have all the best dresses and that I never need another one ever.
This is usually a temporary conclusion I come to every time I look
through my closet and discover things I didn't even know I had.
It is a liberating and fulfilling experience to think one never needs
another dress, like having achieved something after much strife.
Then I get in the presence of other dresses and I realize how
many dresses there are in the world and my favorite dress becomes not the one that
hangs in my closet, but one out there somewhere waiting to be found. This experience
makes me realize how wide the world is. It goes to show me just how little I know
about anything and that there is so much out there
that I haven't seen or even imagined.
It would be a small miracle to
hear from you.

Con cariño,
Lola

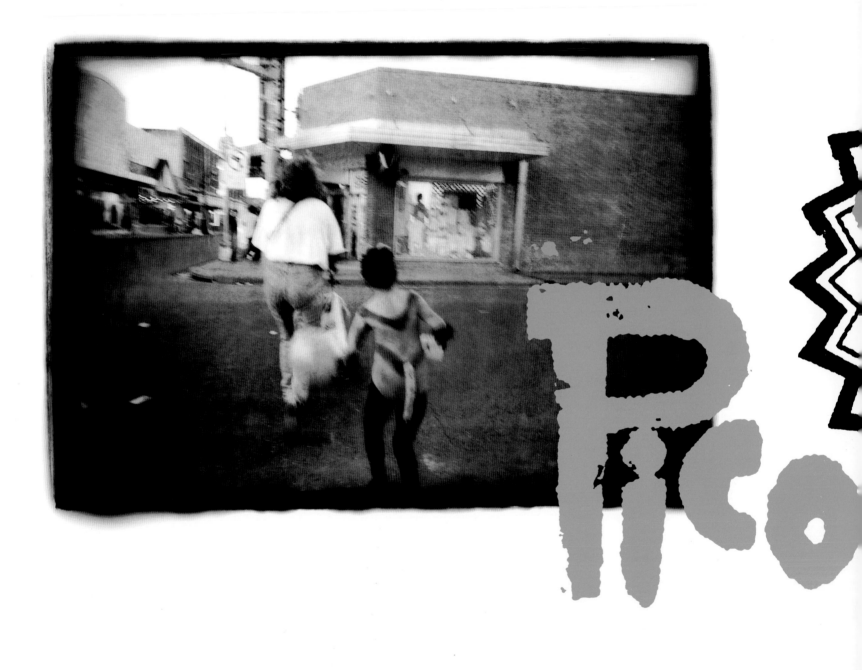

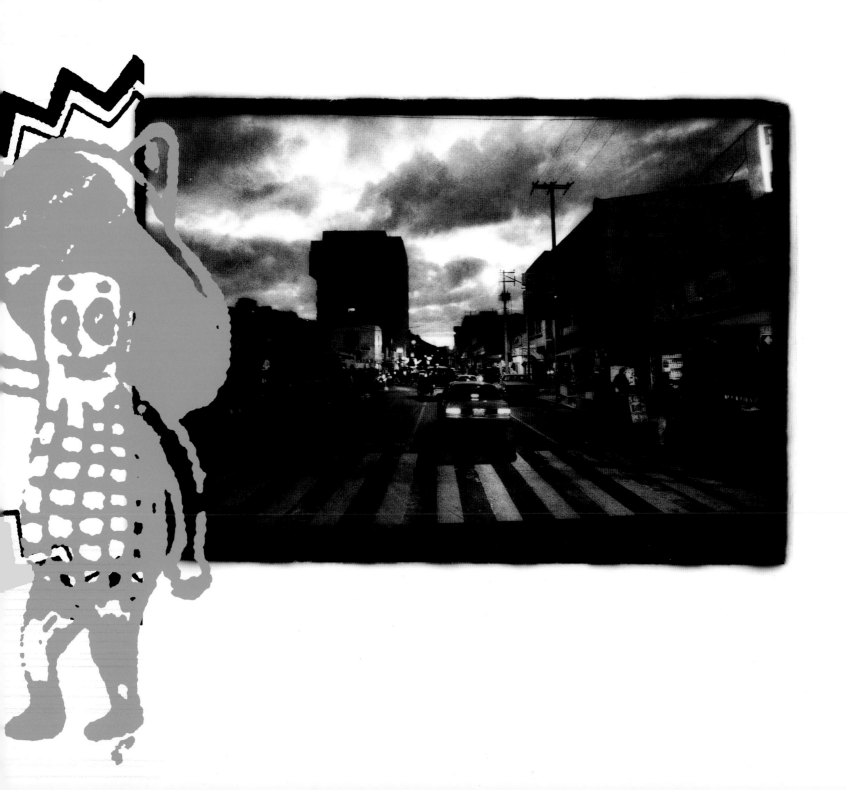

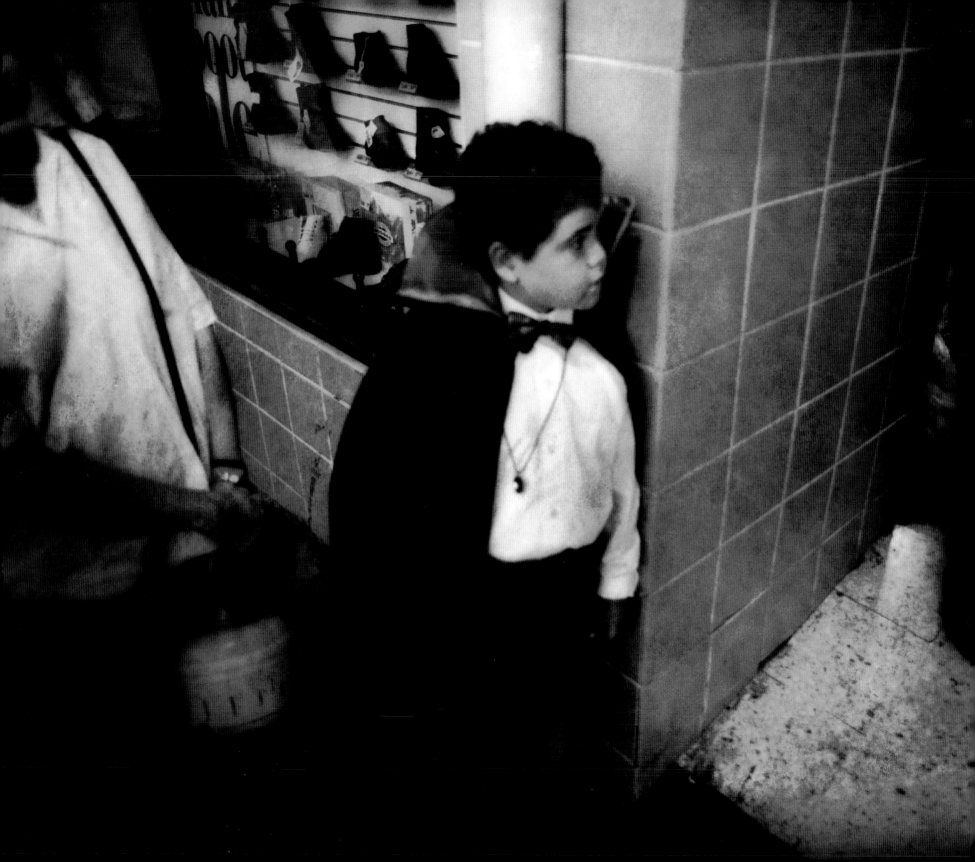

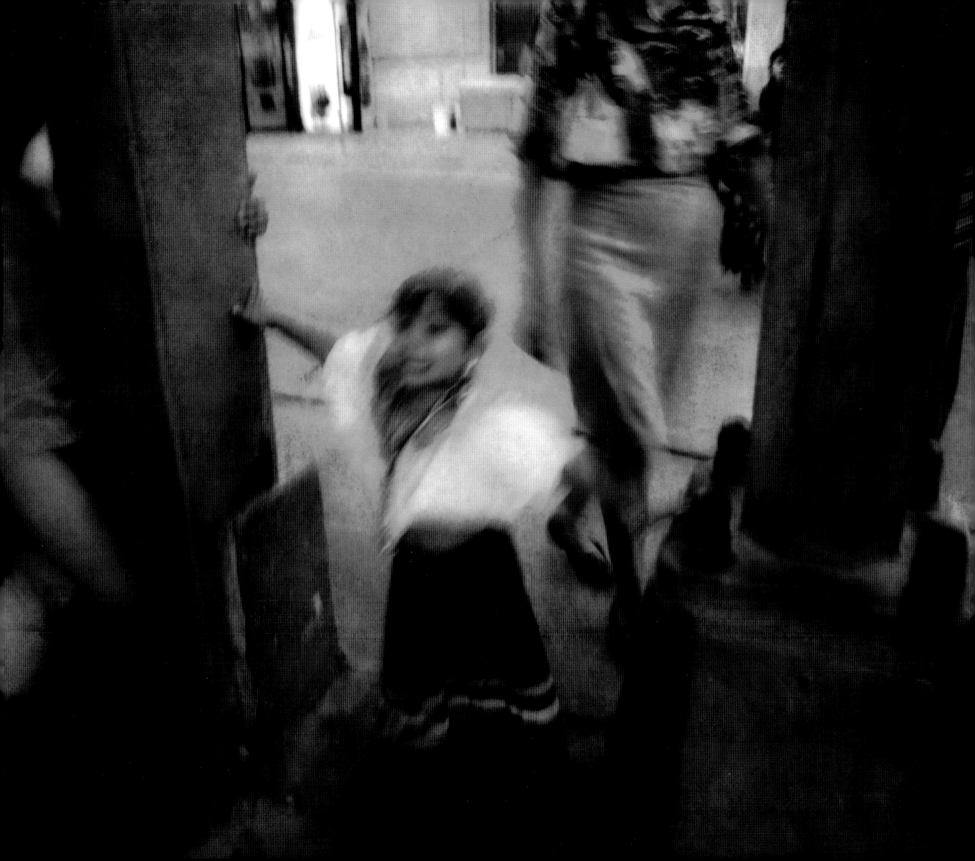

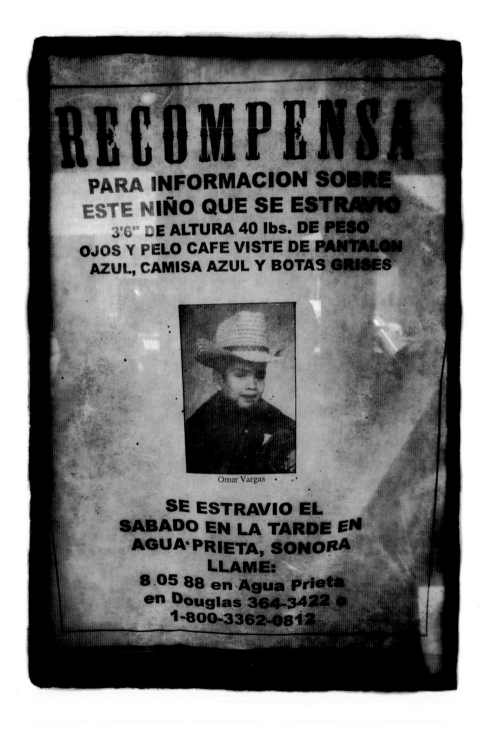

MAHARAJA'S

CADILAC NUEVO HOGAR

VIAJE ROMANCE

You will in the Near Future Meet Someone That Will Alter Your Future for the Best.

PROTECCION

MASCOT

ta "MASCOTA" tendere consisted, aun hasta
ño. Luego de noche tome debajo de su
eve esta "MASCOTA" for 9 dias, luego
, y haga una pedición.

Nº 18956

ON HALLOWEEN NIGHT in Nuevo Laredo, a kid about seven years old wearing socks, no shoes, came up to me wearing a mask, pulled it off and asked me for a quarter. Instead of a quarter, I gave him a wild cherry Lifesaver. He smiled, took it and popped it into his mouth, then walked across the busy street, weaving his way among the cars in his stocking feet. When he got to the other side he turned to me, still smiling, and waved.

Police raid
A police officer secures a suspect after an alleged auto chop shop was raided Thursday. Fourteen people were arrested in a massive surprise raid

Tiempo de Laredo

Aide says governor appalled by INS action

Austin

Gov. George W. Bush is upset with federal immigration officials after receiving reports that at least five people with criminal records have been naturalized as U.S. citizens and are living in Texas, a Bush aide said.

Bush spokesman Ray Sullivan said the governor received reports this week that five individuals living in Texas were naturalized during the last fiscal year even though they had criminal records ranging from driving while intoxicated to aggravated sexual assault.

Sullivan did not have details on the individual cases, but he said Bush was shocked the INS could let such a thing happen.

CORRECTIONS

A Texas Poll story that ran Saturday incorrectly identified Puerto Ricans as illegal immigrants. Puerto Ricans are American citizens.

To the editor:

Compliments are due the editorial staff of the *Laredo Morning Times* for its decision to take a stand against the usual "patrona" politics of South Texas and endorse the candidacy of Jim Whitworth as District 21's State Senator.

It takes courage to go against the entrenched machine politics long associated with South Texas.

The citizens of Laredo need to be free of the fear, intimidation and harassment that are associated with single party, patron politics. The first amendment's freedom of speech has been routinely abused for many in our community; even the right to display a political sign or bumper sticker brings harassment and threats.

A strong two-party system will help to alleviate this type of discrimination, and will allow a true freedom of choice among political candidates.

Let's stand up for our community; let's stand up with Jim Whitworth for good government.

Signed,
Ronald LaDuque

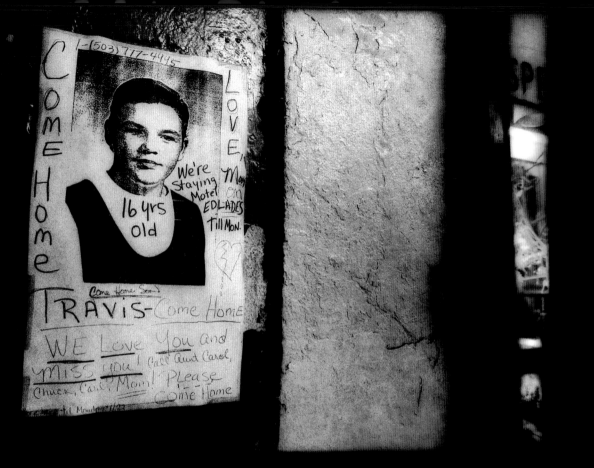

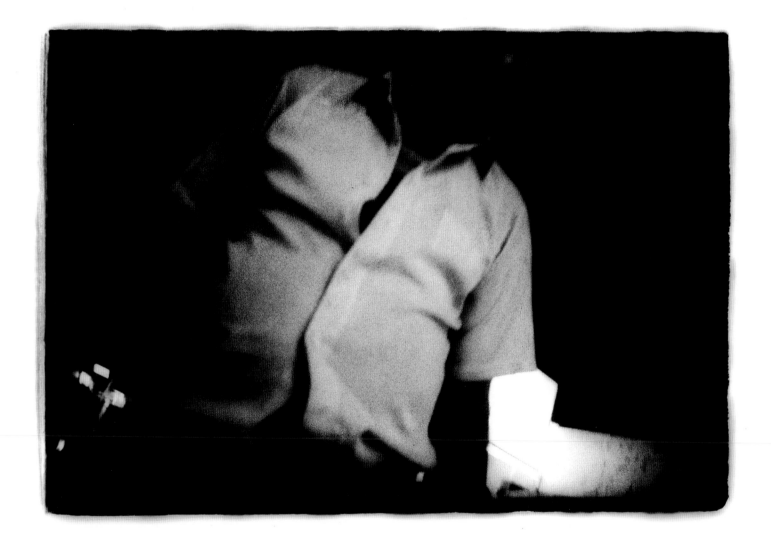

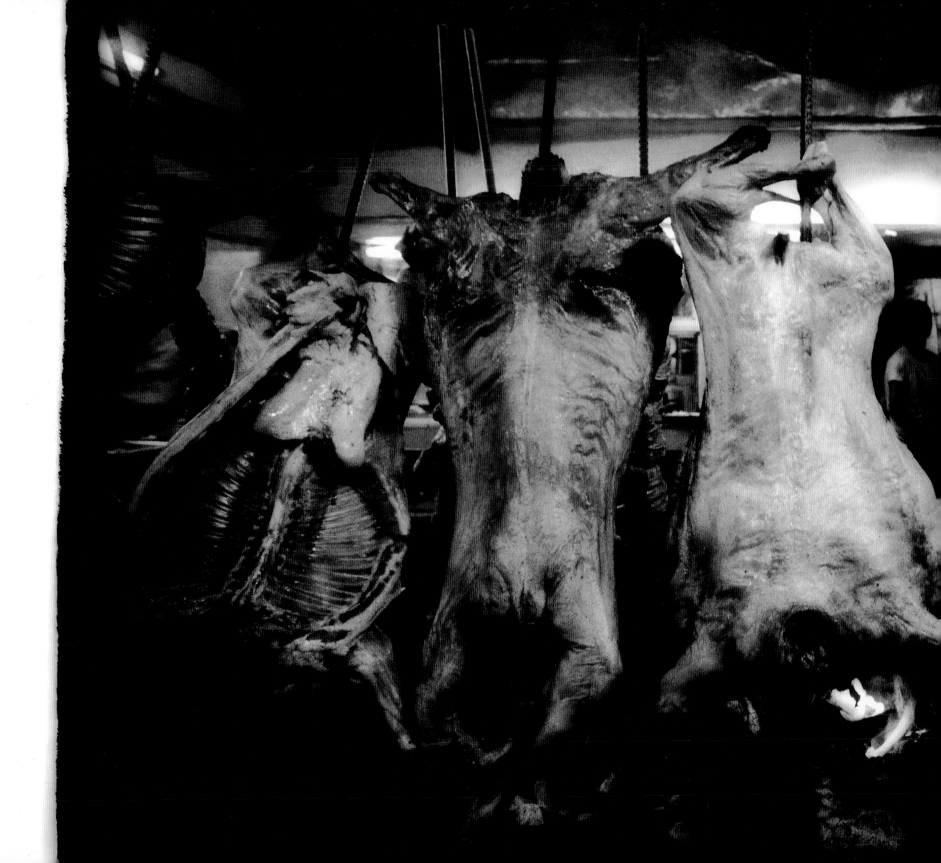

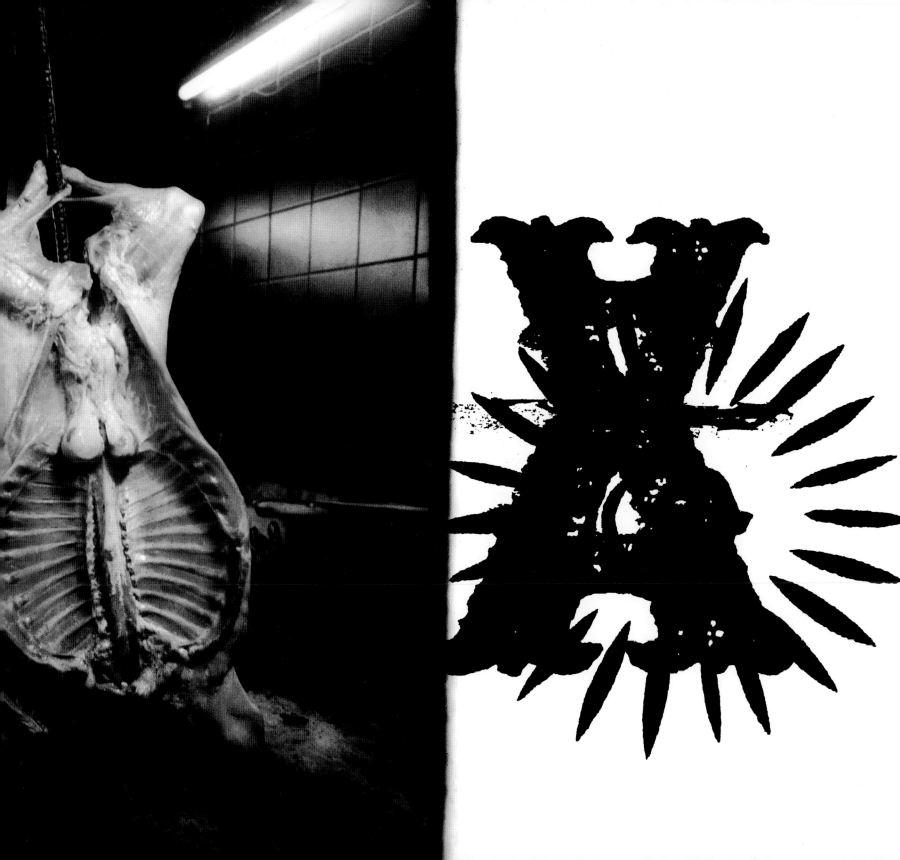

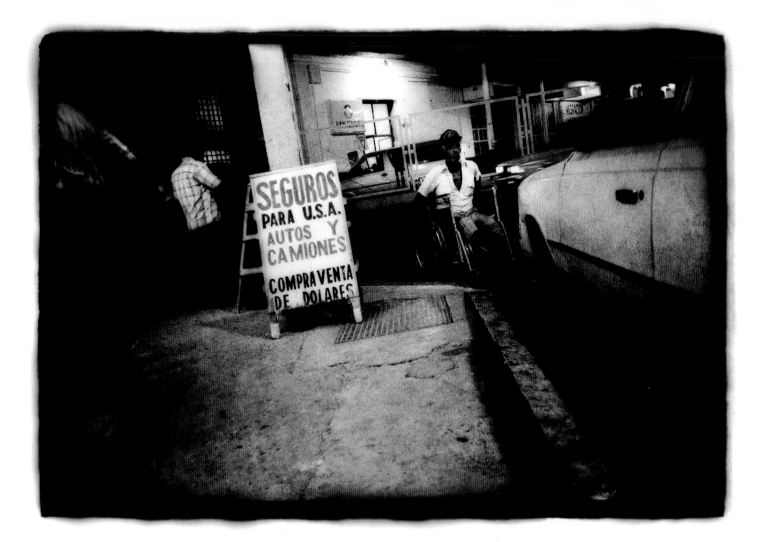

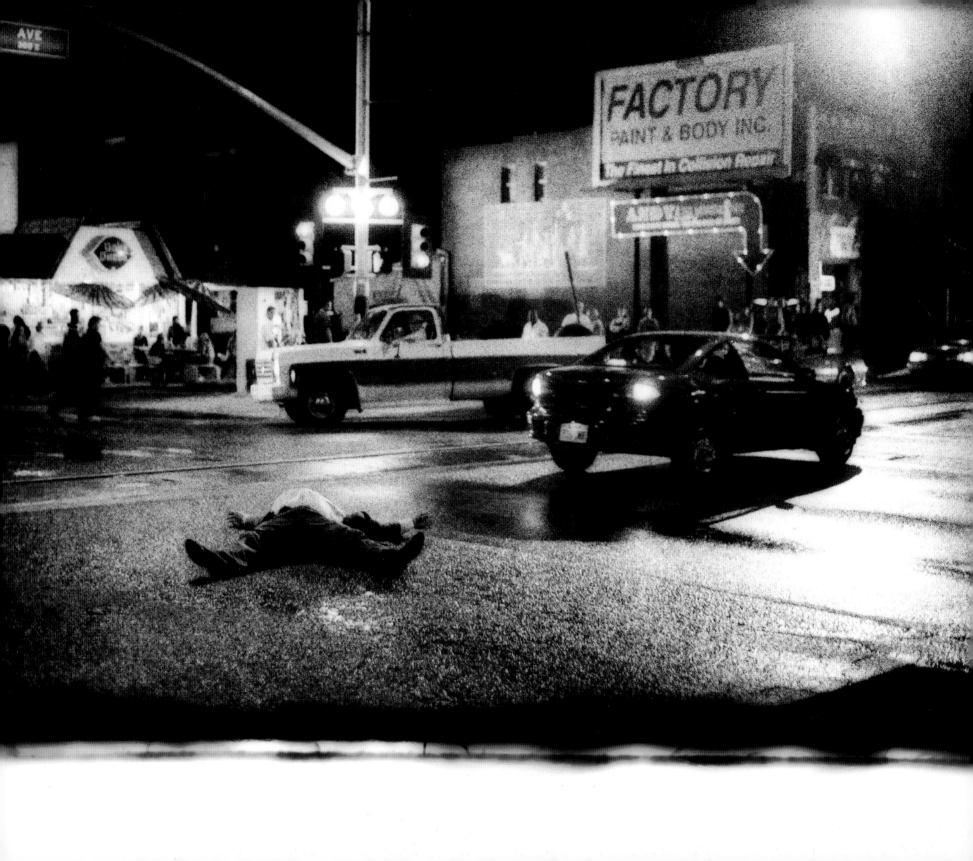

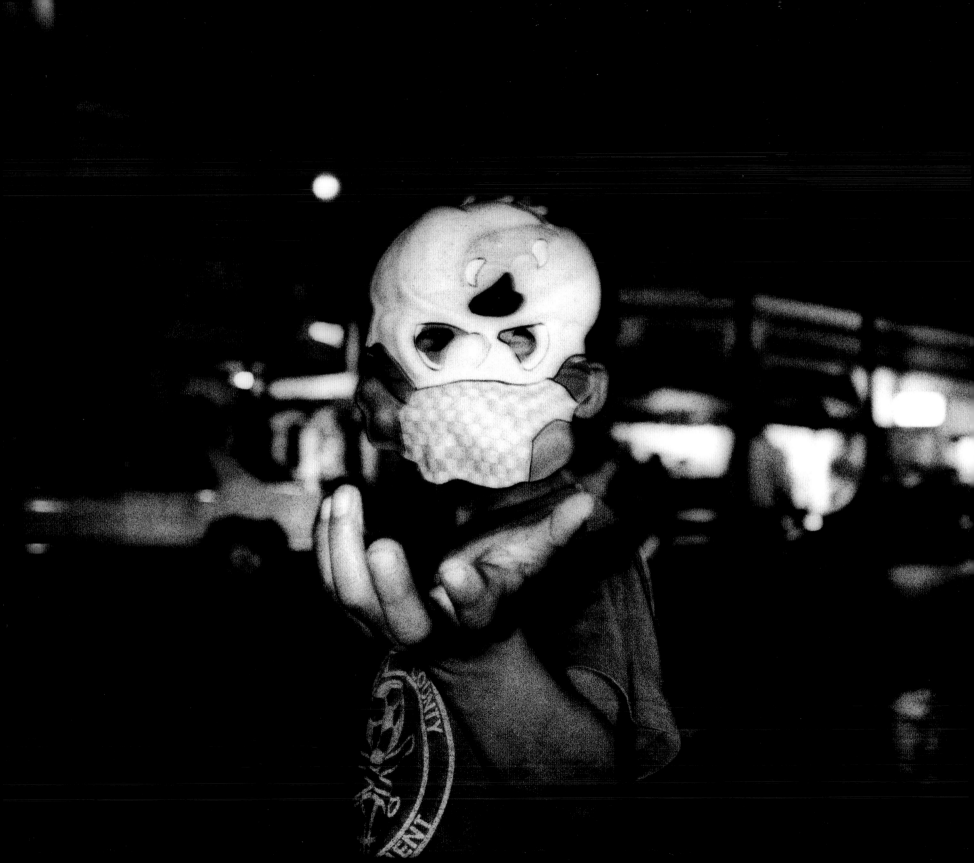

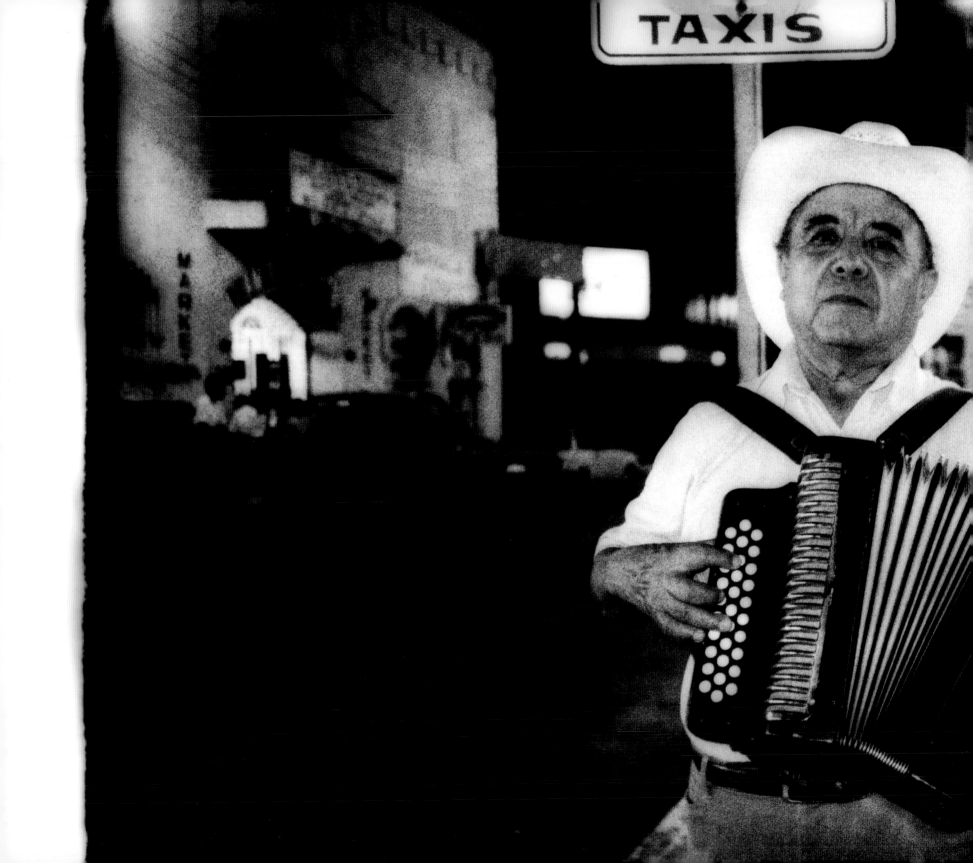

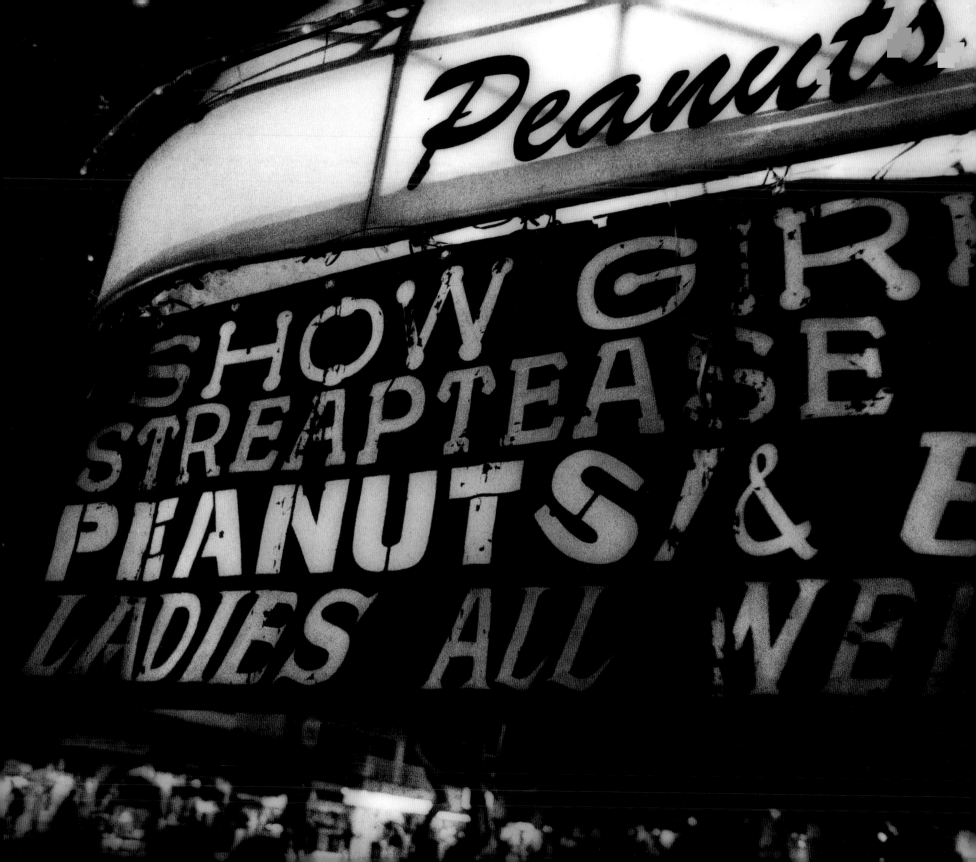

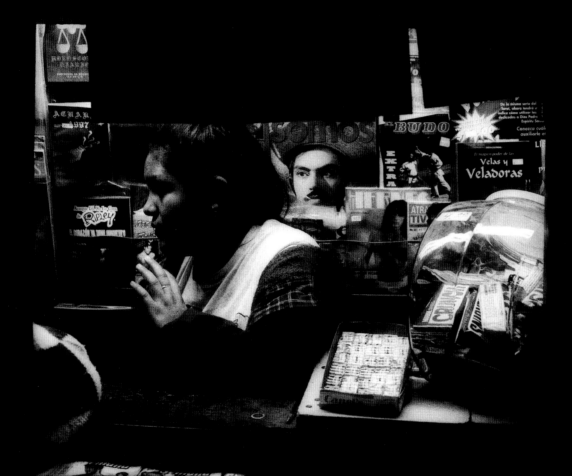

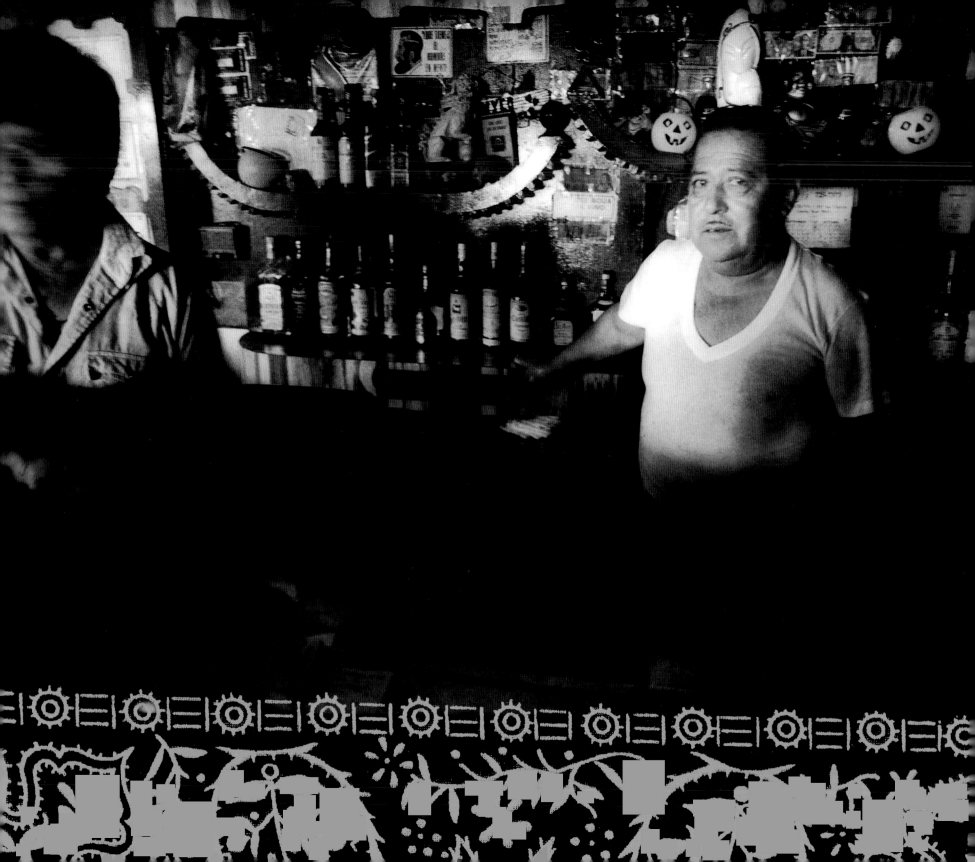

AT BOYSTOWN the girls and women (minimum age: eighteen, though I spoke to one girl who admitted to being seventeen, a miniature beauty with a beguiling schoolgirl's grin) are lined up inside the cuartos, some standing in the doorway actively soliciting, others lying on their beds, a few with TVs on, most (either standing or in recline) reading comic books. Several are stunningly beautiful, Aztec or Mayan princesses in their late teens or very early twenties, a few as lovely as Dolores Del Rio but born into exceedingly mean circumstances, country girls who charge ten dollars for a combination blow job and lay. The women in clubs are the elite—they speak English, are better taken care of, and charge fifty dollars for the same. All of them are examined twice weekly by the Boystown doctor, on Sundays and Fridays. The girls in the cribs pay ten dollars a week rent for their primitive little boxes. Some are sparsely furnished, usually with a photo or two of their tiny son or daughter who is back home in Monterrey or San Luís Potosí, a few Catholic trinkets, a mirror. Others are almost or entirely devoid of any decorative aspect, lit by a harsh overhead bulb, the walls gray, only a thin blanket or sheet on the bed, a plastic bucket of water in a corner.

Fuzzytown
Bar

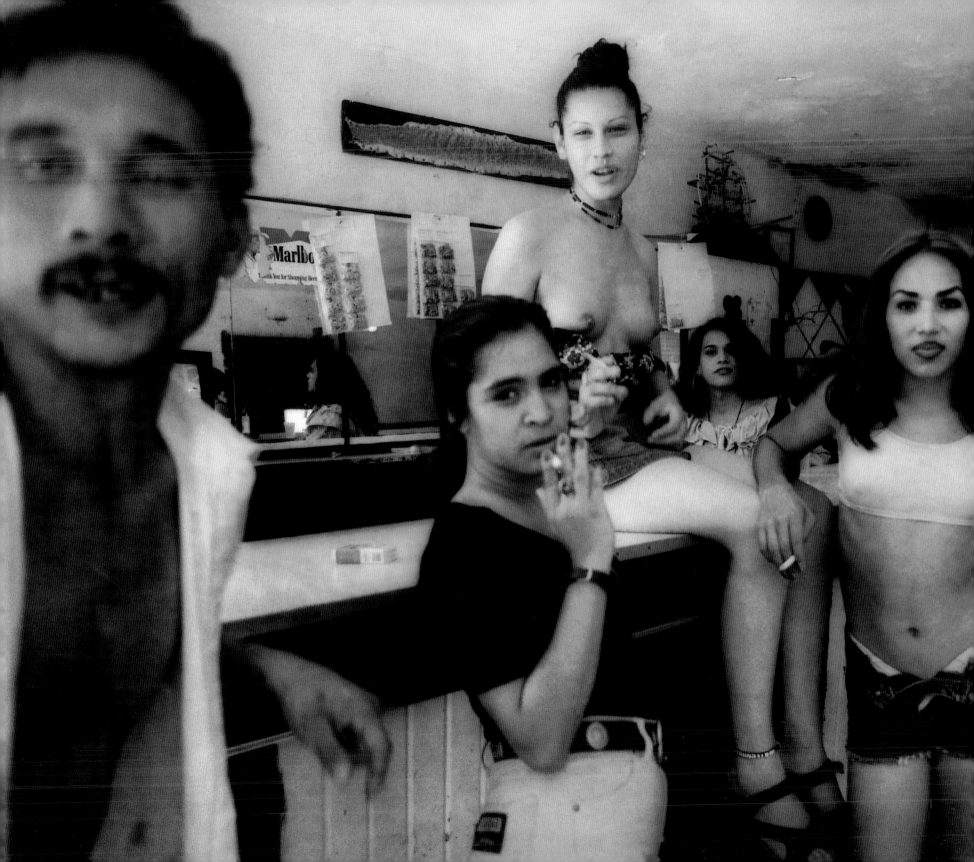

ALL OF THESE PUTAS are carefully made
up, most overly so—as such they look like
typical American high school girls in certain big
cities and suburbs today, where the style is to be
painted up like a Mexican whore. The women must
make their tricks wear condoms, but for a couple of
bucks extra nobody in charge will know the difference
until they show up HIV positive. A few forlorn-look-
ing Indian girls, very short, stout, stand unblinking and
stiff in front of their rooms like dull ceramic dolls on
a shelf, rarely dusted and ignored compared to their
flashier competition. In some doorways two or three
of the younger girls, maybe from the same town, sit
together, joking, coming on to the parade of shopping
dicks, never forgetting why they're there. The girls
are easy to talk to, most—even the older women—still
somehow sweet and innocent. Fucking and sucking is
their business, that's all, nothing emotional in that.
The policía stationed near the entrance in a cuarto of
their own protect the women and make sure each vehi-
cle of visiting gringos pays twenty dollars to enter the
compound.

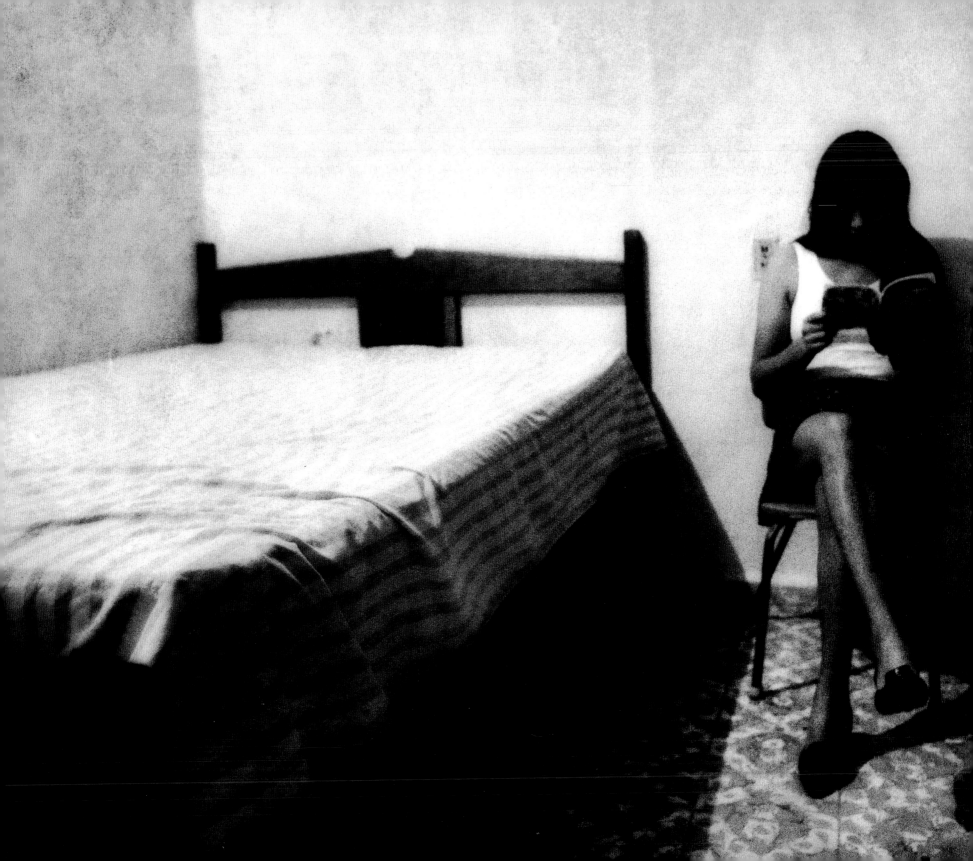

DAVID PAYS SEVERAL of the cuarto girls ten dollars apiece to pose for him in their rooms. Some of the girls refuse to have their picture taken because of fear their relatives in Chicago or L.A. might see them, or their mothers, always their mothers, and be caused embarrassment; one woman keeps insisting she'd rather "fuckee and suckee" me rather than let David take her picture, but she finally relents and allows him in, leaving her door open. Other girls insist on closing the door so it appears that she is turning a regular trick. A heavily made-up, very cute young girl—she's nineteen—named Jacqueline offers to jack me off for free, which shocks our companion, Alejo, a Laredo taxi driver, who says he's never before heard one of these girls make such a proposal. Jacqueline says maybe once she gets me inside and aroused I'll change my mind and fuck her. David photographs Jacqueline and her amiga, Angelita, together in Jacqueline's cuarto with me in attendance. They are lively, quizzical, especially Jacqueline, who is full of good humor in comparison to the rest, who are dead behind their lovely, painted eyes.

Whores in the Club Papagayo

I prefer the cheaper girls in their cuartos to the more expensive women in the clubs—there is less guile in them, they seem less hard, their sadness more palpable. Maybe I'm deluded or just wishful, but they are decidedly tender in the tropical Mexican Laredo night.

Under dim
red
light
purposeful reptiles
slide
from muddy
banks
into green
slimy water

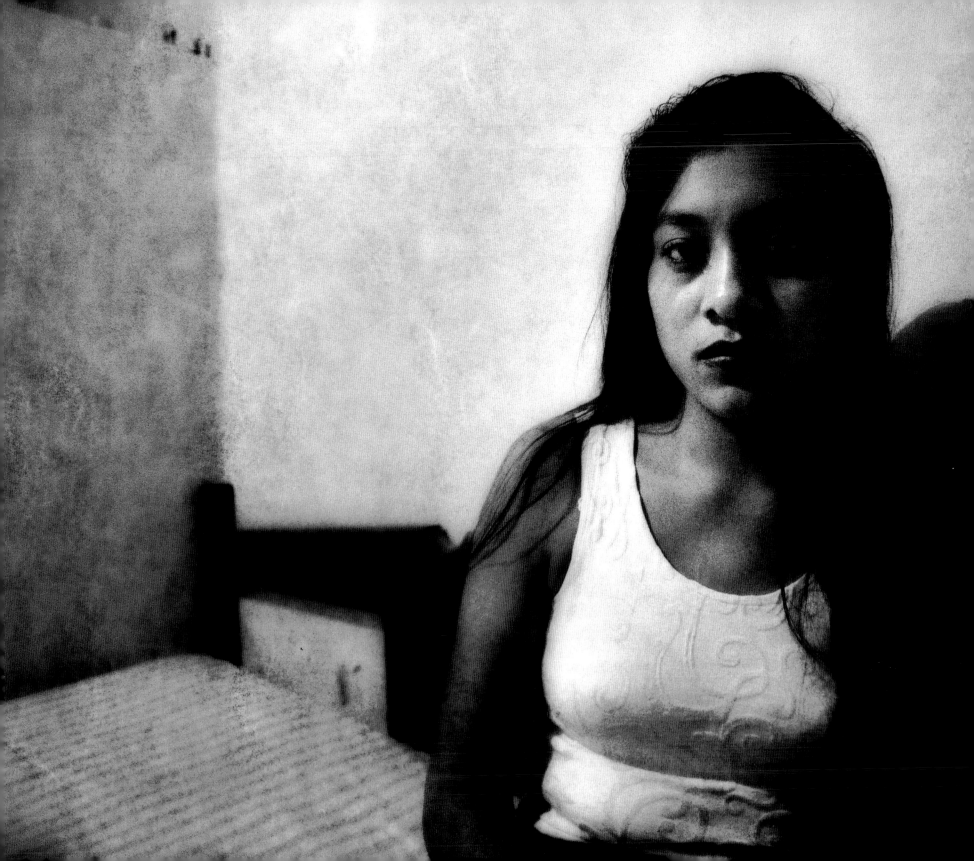

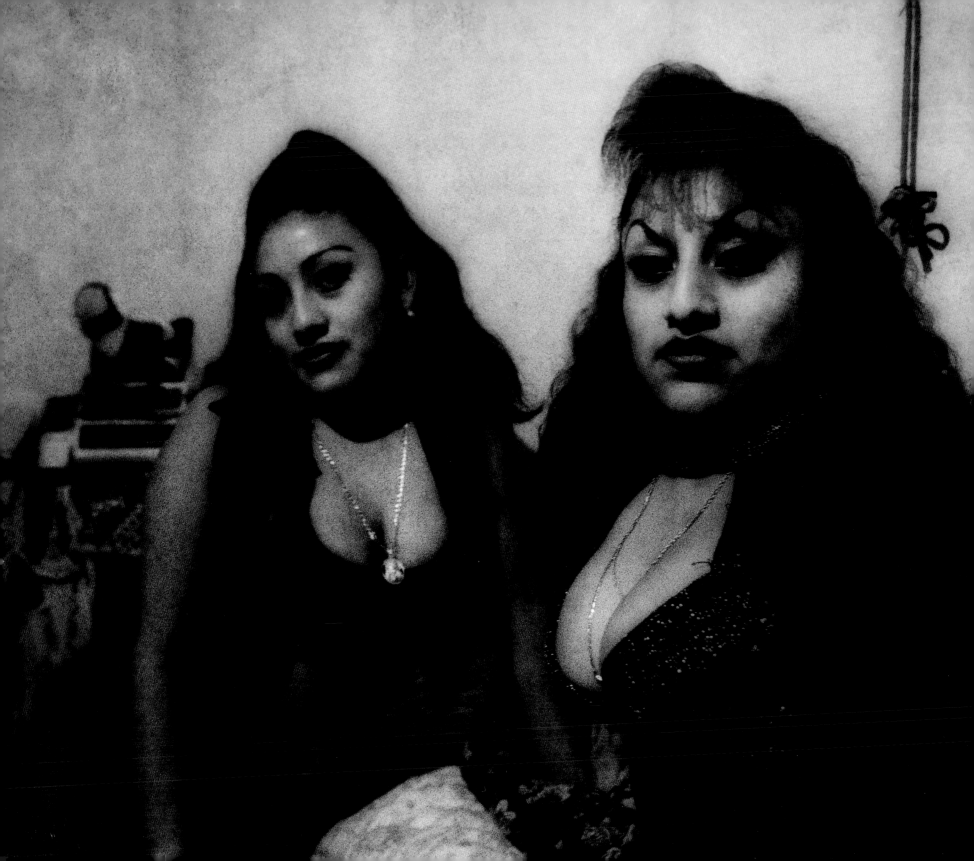

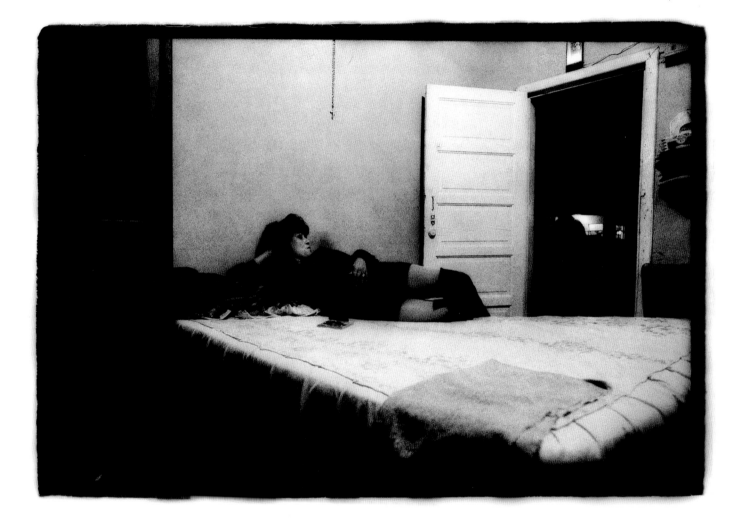

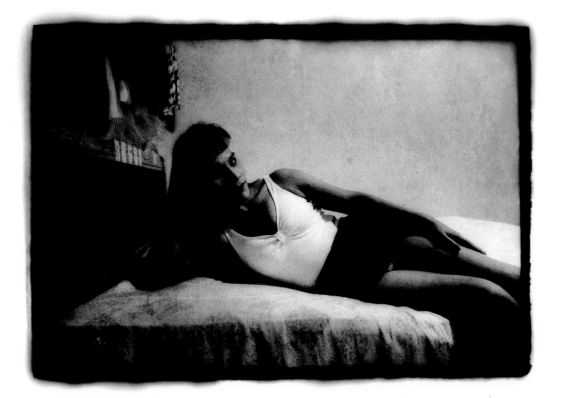

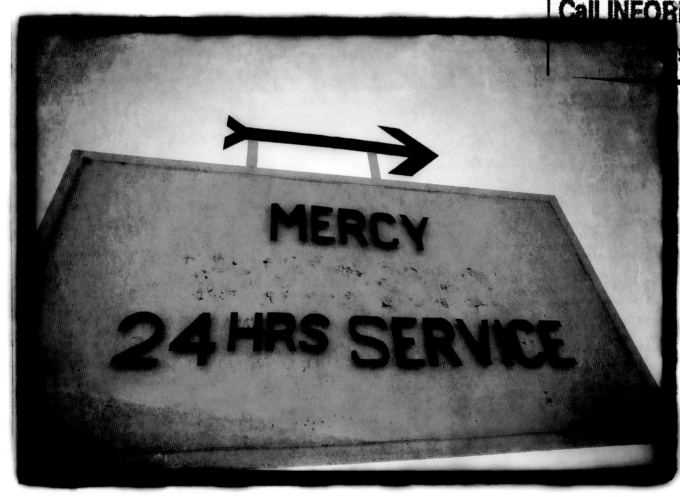

For
Tales of Romance...
Call INFORME at 712-INF
gory 6933

VIETNAM WAR

HONOR ROLL

THIS IS AN UNSPOKEN
TRIBUTE TO THE VALIANT
MEN WHO FOUGHT AND DIED
IN ONE FINAL MEASURE OF
DEVOTION TO COUNTRY

THE MOTHERS OF THE FALLEN
VIETNAM WAR HEROES
LAREDO 1969

HERBERTO ARNALDO
ALEJANDRO GARCIA, JR.
RTINEZ RODOLFO GUADALUPE GON ALEZ

DIETER W. DIETZ
JAVIER ARTURO SAN EZ
RAUL VILLA
JORGE SOSA
JUAN JOSE GONZALE
GUADALUPE MARTI
IGNACIO TORRES,
HOMERO PEREZ
JUAN CARRILLO
VAL "BILL"
ARMANDO

el dia de
muertos
1996

10 Feared Dead in River Crossing

Brownsville, Texas

As many as 10 illegal immigrants were believed to have drowned while trying to sneak into the United States from Mexico by crossing the Rio Grande.

Cameron County Sheriff's Department Chief Deputy Joe Elizardi said witnesses saw 10 people walking along a sandbar on the river at Boca Chica beach near Brownsville on Sunday when a wave swept over them and flushed them into the Gulf of Mexico.

A Large Group Of Treacherous
*** LIONS ***
From The Darkes Jur gle Of Africa
Traine ** But Not Tamed
At King Royal Circus

Harlingen mo
60 years in sho

ASSOCIATED PRESS

BROWNSVILLE — A Harlingen mother has been sentenced to 60 years in prison for killing her son and wounding another in a shooting spree at the family's home last year.

Jurors Friday sentenced Olga Marciela Torres to 45 years in priso for murder and an additional ears for attempted murder i Aug. 7, 1995, shootings.

Mrs. Torres, 41, sat passively as the jury read its sentence. Her younger son, 9-year-old Steven Ray Torres, died in the shooting, while 12-year-old Willie Joe Torres was wounded.

Mrs. Torres had faced up to life in prison on the murder charge and a maximum of 20 years in prison for attempted murder.

Defense attorneys had asked for probation so that Torres could re-

ceive psych help. They argued she is s ly depressed and could not d sh right from wrong at the the shootings.

On Thursd lie Joe, now 1, tearfully ple with jurors to give his mo robation, saying she deserve ht senten to prove that t that typ person. ... S ver been tha way before."

During qu g by defense attorney Ern mez Jr., Willie recalled how other used to help him wit English lessons and reading.

He told jur mother was always there fe always ready to help him choolwork, and attended pa involvement programs with

Assistant D Attorney Elsa Salinas was o d that defense attorneys call llie to testify.

Día de los Muertos

Mujeres indígenas de la tribu Tzotzil adornan la tumba con flores de los muertos y velas en el pueblo de Romerillo, durante la celebración del Día de los Muertos..

Harlingen — Hispanic women living along the Texas border are diagnosed with cervical cancer at twice the rate of whites and are twice as likely to die, a study says. Health officials cite cultural and financial barriers. ... S

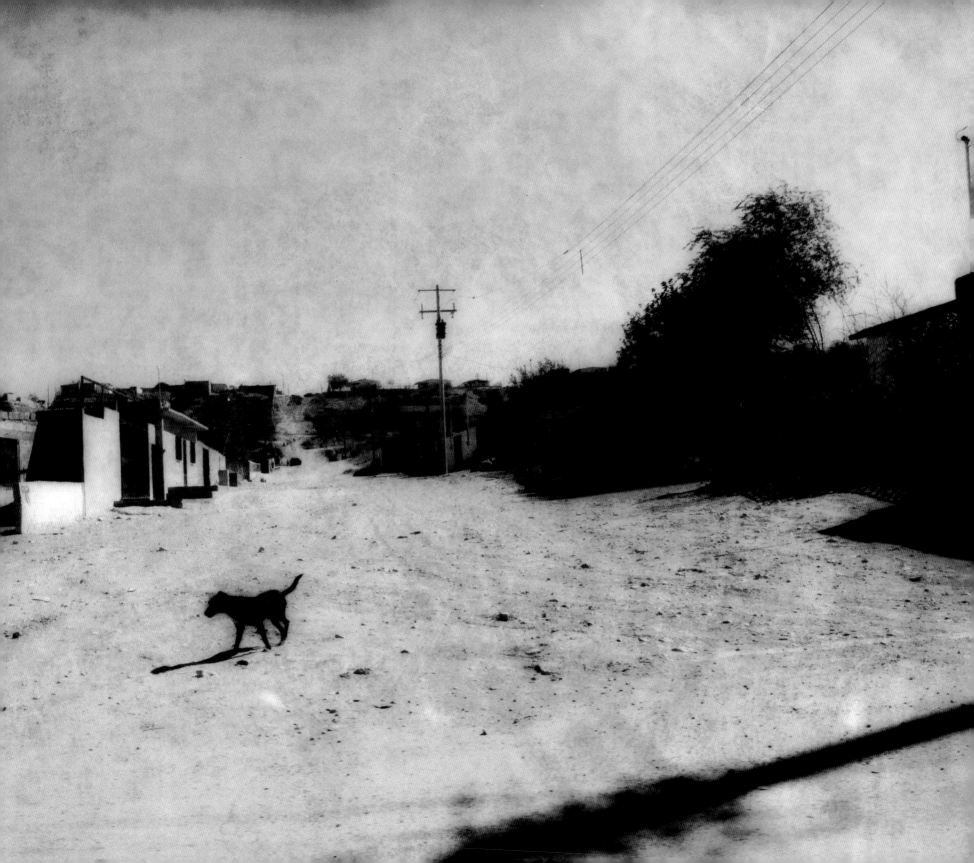

...gin on front of
...n Agustín church
...ays that concealed
...eapons are not
...allowed in the

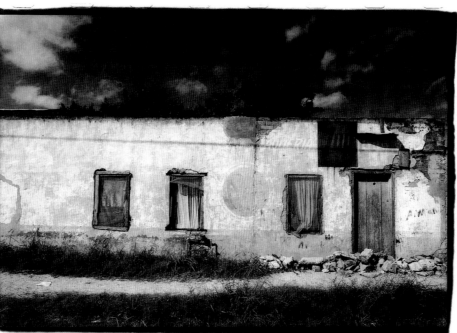

UNDER A
GIGANTIC
BIG TOP

...ouse of God.

Highway 83

In Zapata, Texas
 I saw a Mexican
 girl
 driving an
 old Dodge pickup
 She was so beautiful
 for one moment
 the earth
 stopped spinning
 and everything that
 ever
 happened
 to me
 made perfect
 sense

Our masthead

The *Times* masthead topped with the
seven-flags logo is symbolic of Laredo's
historic link to seven countries — that of
France, 1685-1690; Spain, 1519-1685,
1690-1821; Mexico, 1821-1836; Republic
of the Rio Grande, January 1840-late fall
1840; Texas, 1836-1845; Confederacy,
1861-1865; and United States 1845-1861,
1865-present. This region was once part of
lands claimed by France, governed by
Spain, Mexico, Republic of the Rio Grande,
Texas, Confederacy and now pledges alle-
giance to the United States.

HE MANAGED TO ESCAPE TO
MEXICO, BUT THE EXPERIENCE
WAS SO HUMILIATING THAT HE
DECIDED TO GO STRAIGHT.

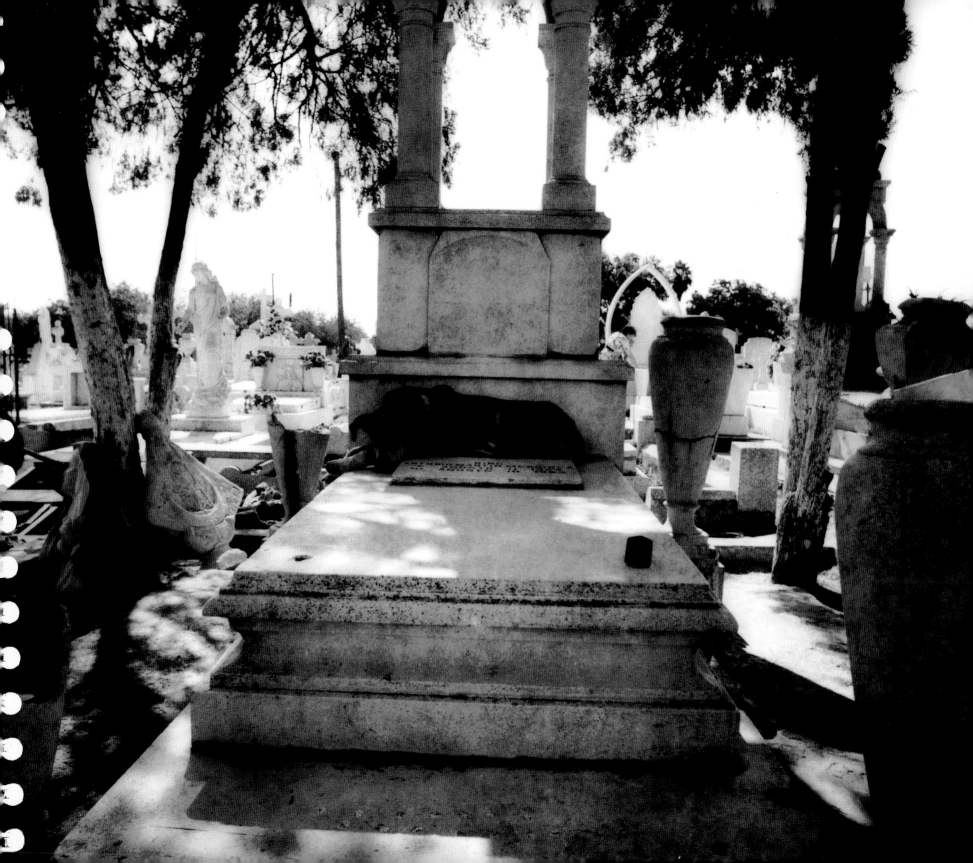

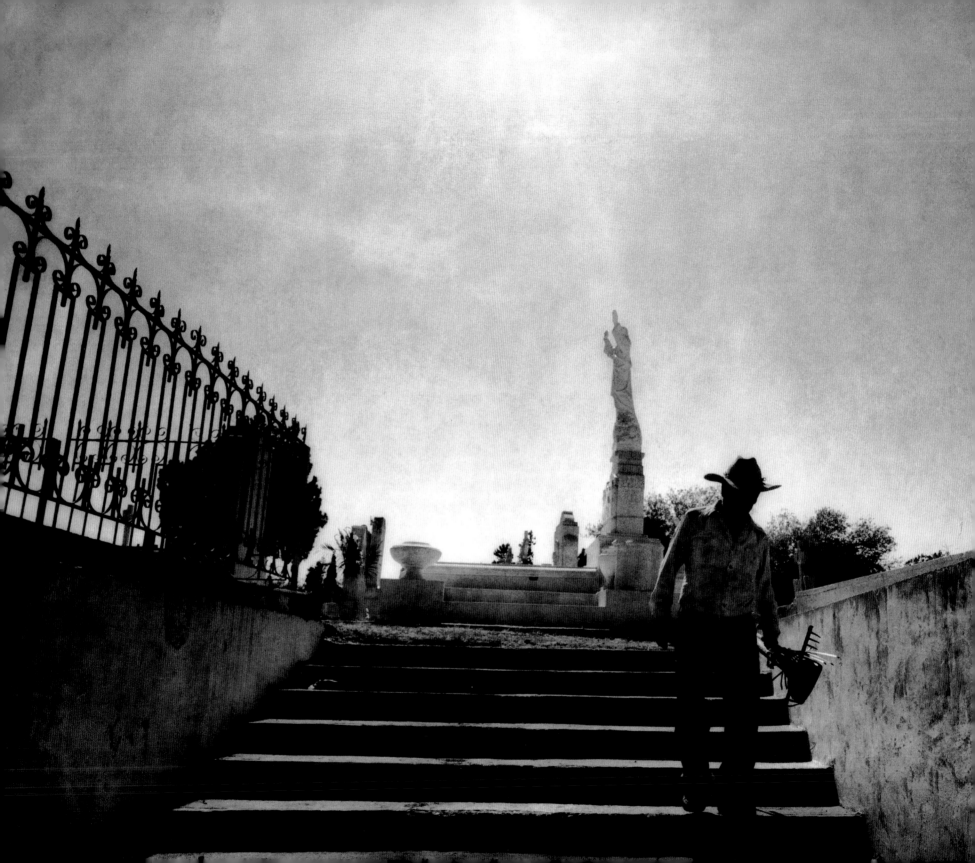

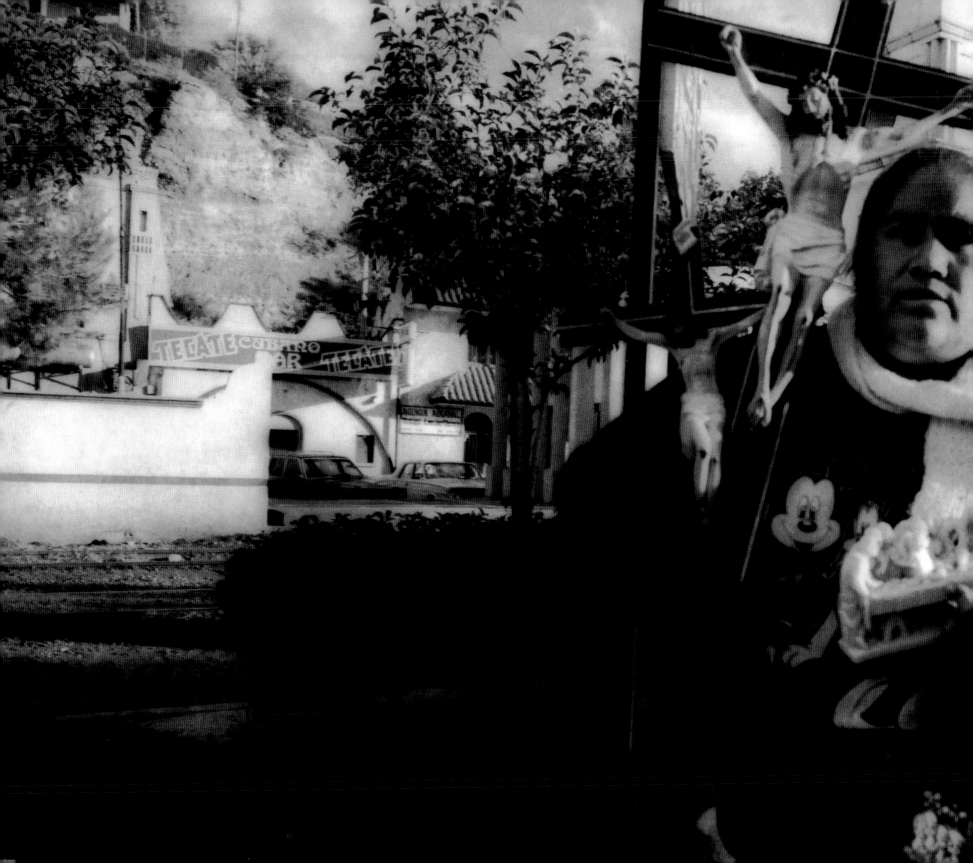

EVEN AT DAWN, Nuevo Progreso reeks of the stench of American death. In contrast to other border-towns on the Mexican side that stink of garbage, raw sewage and sweat, Nuevo Progreso, just across the river from Progreso, Texas, is almost antiseptic in appearance. It's a tiny town with new sidewalks and tidy shops, most of which are farmacías at which the parade of elderly Americans line up to buy their antibiotics and other drugs that are much more expensive in Texas. Nuevo Progreso is the opposite of Castela, which has nothing to offer Americans, or even Agua Prieta. N.P. exists for the convenience of (mostly) elderly Texas tourists.

Barbacoa, Tamales, Menud
Ojas, Masa, Beer, Ice

Cabrito
antes

On October 26, paranoid
drug smuggler is captured
after he falls into a ditch
along hi...
...as,

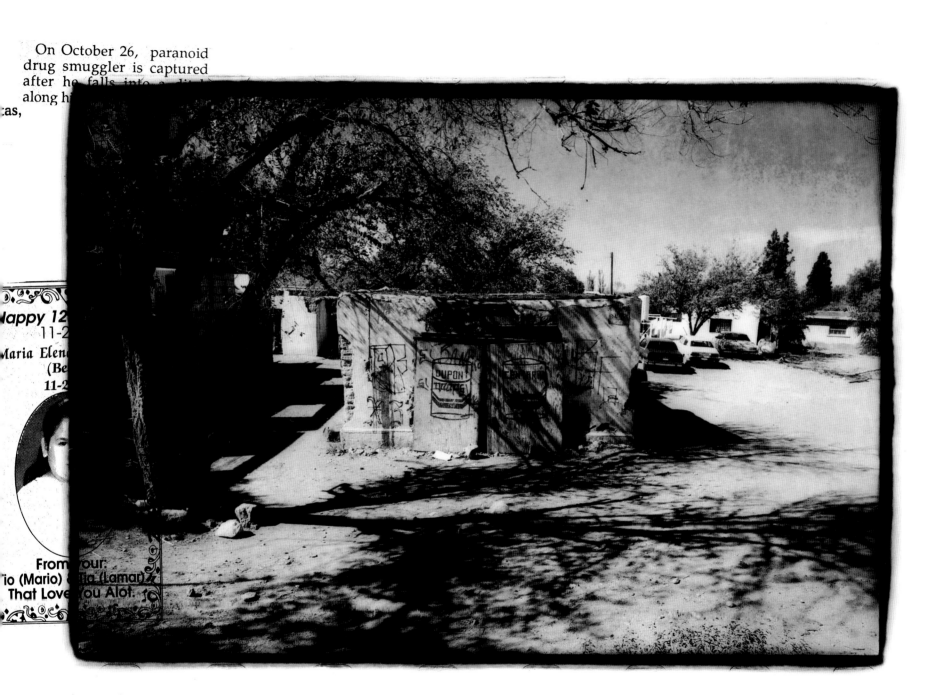

BEING IN PROGRESO also reminded me of the real Progreso, Mexico, in Yucatán, near Mérida. I suggested to my uncle a few years ago, after he sold his house in Honduras, where he lived for 20 years on the island of Utila, that he might like Progreso, a little town on the coast that had good fishing. He went there and loved it. One day Buck arranged to go fishing the next morning with a Mexican guide, but that night he broke his leg and was hospitalized in Progreso. He spent a week there—the doctor, without benefit of an X-ray machine, thought it might be a deep bruise—but it didn't improve, and even though my uncle was well-treated, ordering food from the restaurant downstairs from the hospital, he had to get to Tampa for proper treatment. A local carpenter carved him a pair of crutches and he was driven to the airport in Mérida.

BACK IN TAMPA, my uncle, who suffers from Padgett's disease, a degenerative bone ailment that afflicts his right leg (the one that broke), was told that the only chance he would have to walk properly again was if a titanium rod was placed in the leg, after which he would be bed-ridden for two or three months in order that the bone could heal and knit correctly. It did, and my uncle didn't get down to Mexico again for about a year. When he got to Progreso, he went to the fisherman's shack—of course, the man had no telephone and had never been contacted after my uncle broke his leg—knocked on the door, and when the man answered Uncle Buck said to him, "Well, are you ready to go fishing?" The man looked at him for a moment, then simply said, "Why not?"

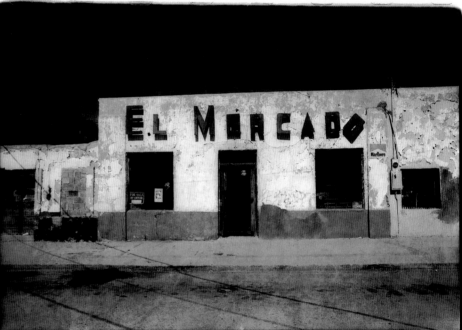

THIS IS AN ANCIENT FORD. First recorded usage was by Spanish explorers and colonists under Jose de Escandon in the 1740s on the Rio Grande. A salt trail led from Los Ebanos to El Sal del Ray. The ford was used by Mexican War troops in 1846; by Texas Rangers chasing cattle rustlers in 1874; by smugglers in many eras, especially during Prohibition in the '20s and '30s. The ferry and inspection station were established in 1950. Named for the ebony trees here, this is the only government-licensed, hand-pulled ferry on any boundary of the United States.

The ferry crossing reminds me of B. Traven's *A Bridge in the Jungle*. El chalal, the ferry, is hand-drawn by five men and can take up to three cars at a time plus several pedestrians across the Rio Grande. A dirt road leads to the town of Ciudad Díaz Ordaz. The original name was San Miguel de Carrargo—it was changed for the president of Mexico who died in 1970. The captain of the post, Captain Simo, told us that President Eisenhower granted permission to build a bridge across the river, and Clinton gave money to Mexico to build a bridge—but, of course, it still hasn't been done, and I hope it never happens.

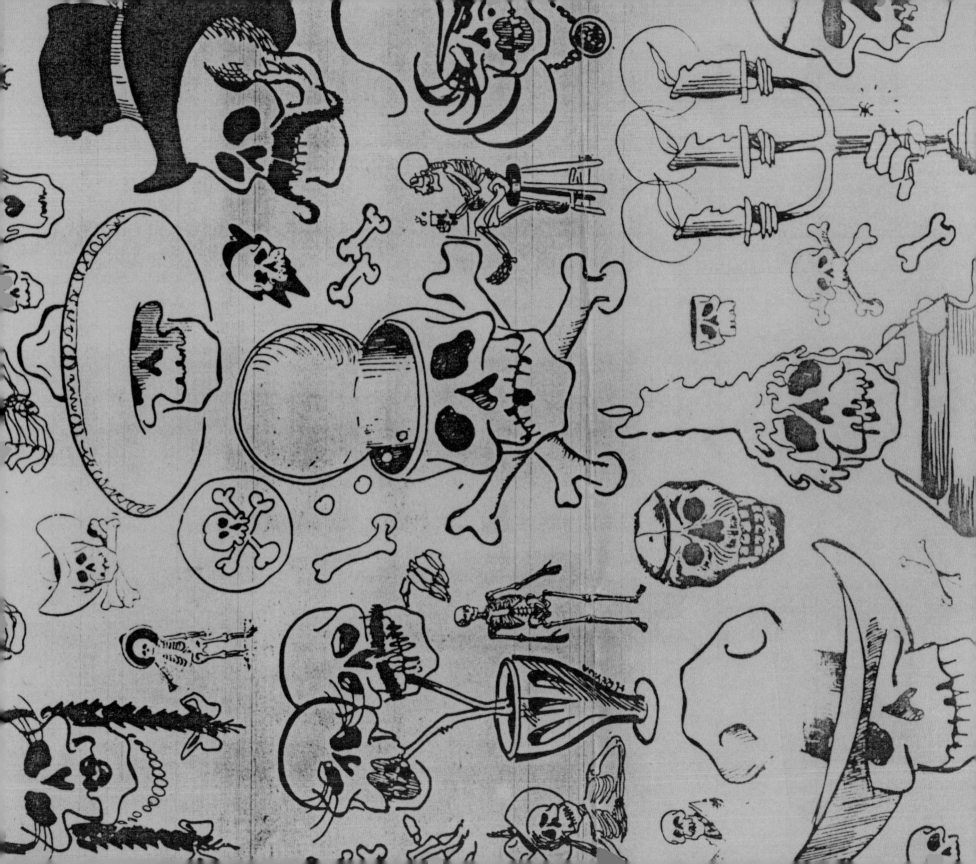

Si lo Ve, RS6

Lo BUSCA.

Llame × Cobrar a Almoloya

IN LA JOYA, we stopped to eat at Ramira's Bar-B-Q, which had excellent chopped brisket. The owner's nephew, Robert, who was working alone, came and sat with us while we ate. He said he didn't like to go to Mexico, it's too dangerous along the border. Nuevo Progreso, he says, is the only "nice" place in the Rio Grande Valley. Matamoros is as "peligroso" as Tijuana, and "Reynosa's a black pit." It's too violent everywhere, Robert said, even around La Joya on Highway 83. He told us a "good" story, though. When he was in high school about ten years earlier, a student who'd moved to La Joya from L.A. fucked a girl at the school then told people about it, saying the girl was worthless now that he'd had her. At a party in Reynosa soon after this, the brother of the girl shot the guy in the head with a .25 caliber handgun. The L.A. guy survived, and today, Robert said, that guy and the kid who shot him are best friends and associates in the same law firm in San Antonio. "What happened to the girl?" I asked. "Who?" said Robert. "The shooter's sister." Robert shrugged his shoulders, and said, "Who knows?"

A SHOPKEEPER in Ciudad Díaz Ordaz gave us this sample of drawings by a local kid who had disappeared from the town. Recently his skull had been found in Mexico City.

SIN

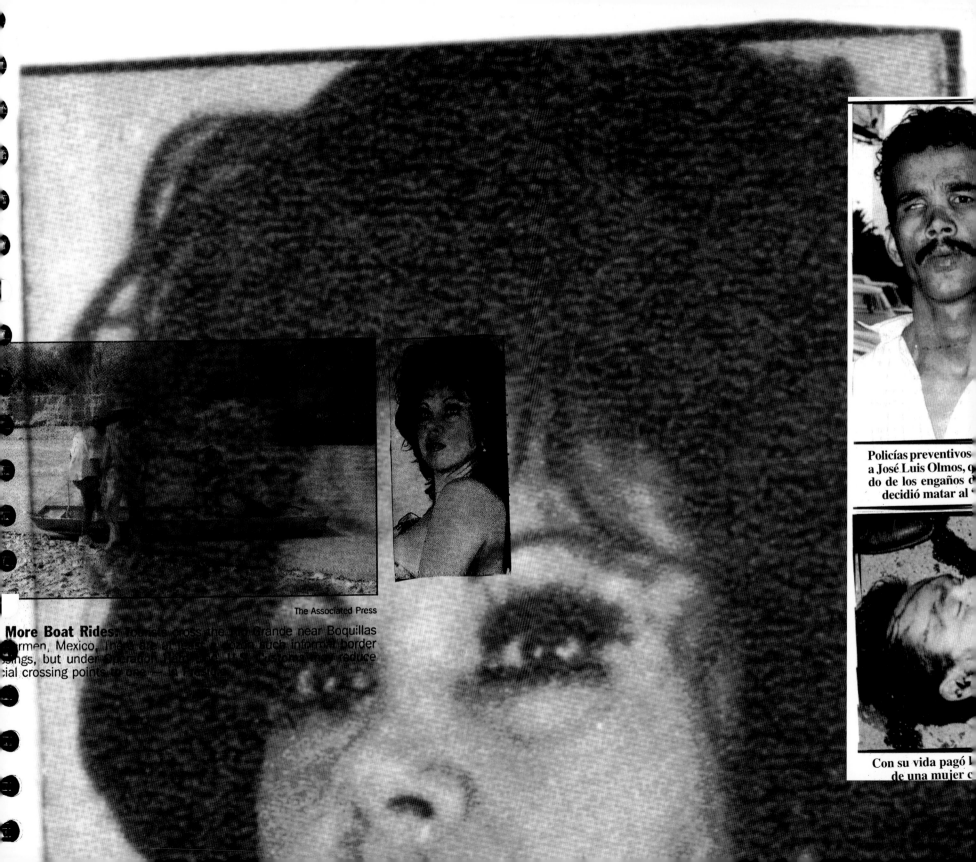

The Associated Press

More Boat Rides: To cross the Rio Grande near Boquillas del Carmen, Mexico, there are currently a few such informal border crossings, but under Clinton administration plans to reduce official crossing points to one...

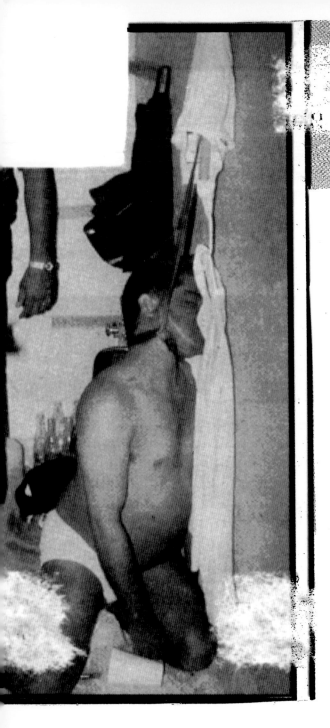

REYNOSA, Tamps.—Un me-
sero que laboraba en un
zona roja denominado i
encontrado muerto colg do
cinturón al cuello, el cu
traba suspendido de un pis

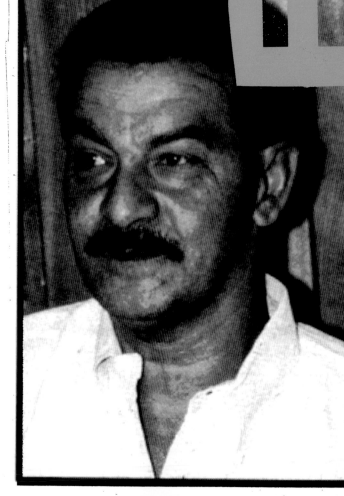

**Abdel Latiff Shariff, "El Egip-
cio". Desde la cárcel sigue mo-**

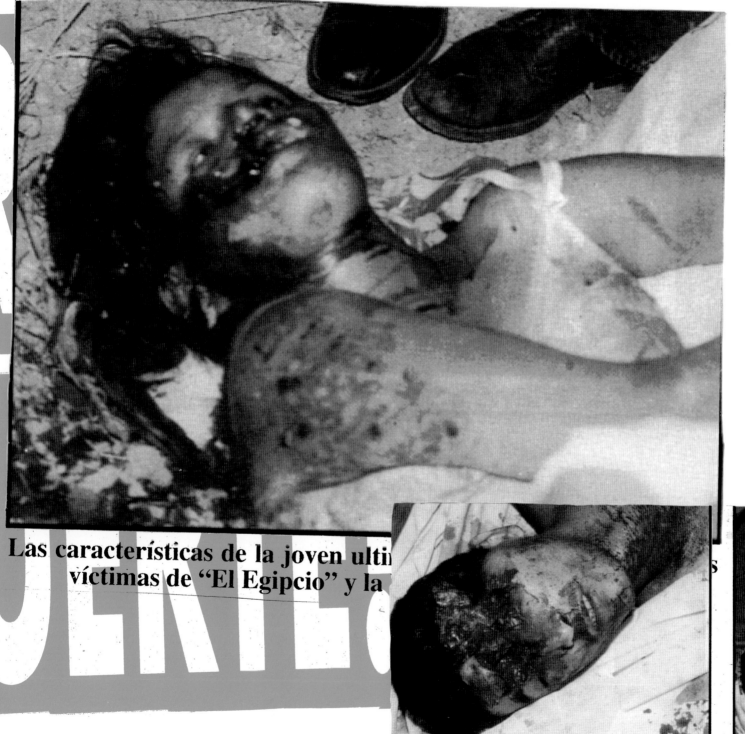

Las características de la joven ultimada [...] **víctimas de "El Egipcio" y la** [...]

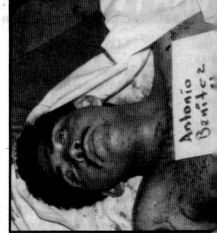

cráneo destrozado quedó el cuerpo de Ismael Olivas Meza, una de las víctimas de los gatilleros.

Antonio Benítez Almeida fue otro de de hombres armados e

MATAMOROS WAS THE LAST STOP on the
Texas-Mexico border trail. Everyone we talked to told
terrible tales of Matamoros, how it's a Mexican Mafia
town, a rip-off tourist city, crime-ridden, etc.

A female bartender in New Orleans once told me she
and a friend liked to go down to Matamoros and "get
lost"...

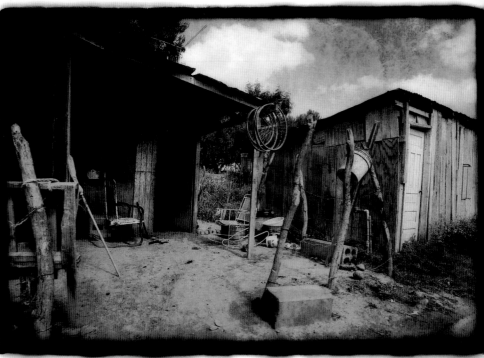

"We get wrecked for a few days, nobody there cares.
That's what's so cool about them Mexicans, how they
don't freak when you go crazy on yourself. Know
what I mean? They're different, for sure. That guy
Howard Stern? The ugly, long-haired guy who insults
people on TV and the radio? Other day he was
talkin' about wantin' to give it to Hillary Clinton up
the ass. Imagine a guy on TV in Mexico insulting
the Mexican president's wife like that! They shoot the
motherfucker or put him in jail for a *long* time.
They got respect for people there, not like here.
They'll let you hurt yourself, do what the hell you
need to do as long as you're not disrespectful to the
wrong people. Know what I mean? It's a good
place to get your head bad, that Mexican bordertown.
And you get it bad so you can get it back good,
right? You been there? Full of crazy motherfuckers, all
kinds of bad customers ready to shop. Just thinkin'
about it makes me want to get in the car and ride
the demon... I love bordertowns!"

IN CIUDAD DÍAZ ORDAZ I asked a taxi
driver if he was a Catholic, because we were passing
several churches, and he said, "No, Evangelico." Of
course most of the people we've encountered are
Catholics. I'm reminded of a situation where a friend
of mine, who was engaged to a girl in another city,
was in a bar getting along particularly well with a
woman he'd just met. He was obviously conflicted,

wanting to remain faithful to his fiancée, and said something about it to me. "Remember what all the Catholic schoolgirls used to say," I told him. "What's that?" he asked. "Blow jobs aren't sex." The next morning he called me up and said, "What about hand jobs?"

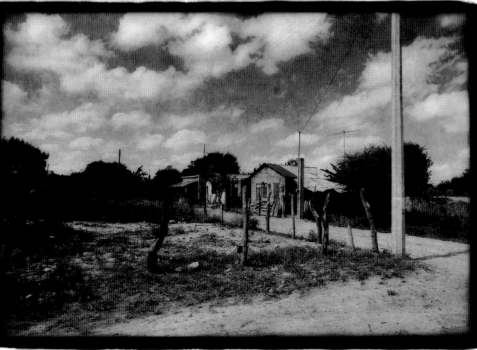

ON OUR LAST NIGHT in McAllen, Texas,

we went to dinner at a restaurant named La Casa del Taco, which, despite its absurdly generic name, had been highly recommended by several people as having the best Mexican food in town. We ate in the smaller of two dining rooms, which reminded me of an old Key West place like the long-gone Fourth of July or José's Cantina. We had margaritas on the rocks, and I ordered crawfish and cebollo, both excellent. But the best part was a little old guitarist-singer named Yuppi, who serenaded the tables, only two of which besides ours were occupied. Yuppi was very happy when I asked him if he knew the songs of Agustín Lara, the great balladeer of Mexico during the 1950s. I requested "Vera Cruz" and "Farolito," both of which the diminutive, Douglas Fairbanks-mustachioed Yuppi played with great relish if not consummate skill. He told me most people request tunes like "You Are My Sunshine," so my suggestions especially pleased him. I tipped him well and he finished by singing "La Golondrina." A young Mexican-American guy—late twenties—sitting with his wife and baby and another couple at a nearby table, said to me that he'd grown up in the Rio Grande Valley—he now lives in Idaho—but he'd never heard those songs like I'd had Yuppi play. Outside after dinner in the parking lot, the wind was blowing hard, but it was a warm breeze from the gulf. "Vera Cruz" was still in my ears.

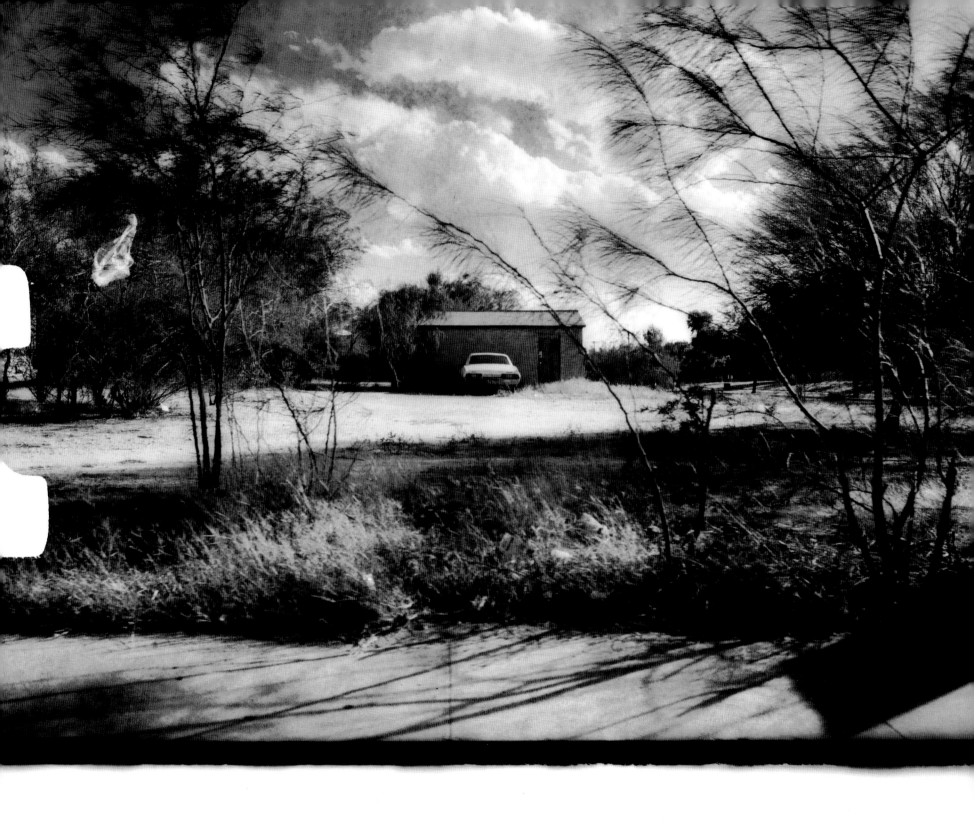

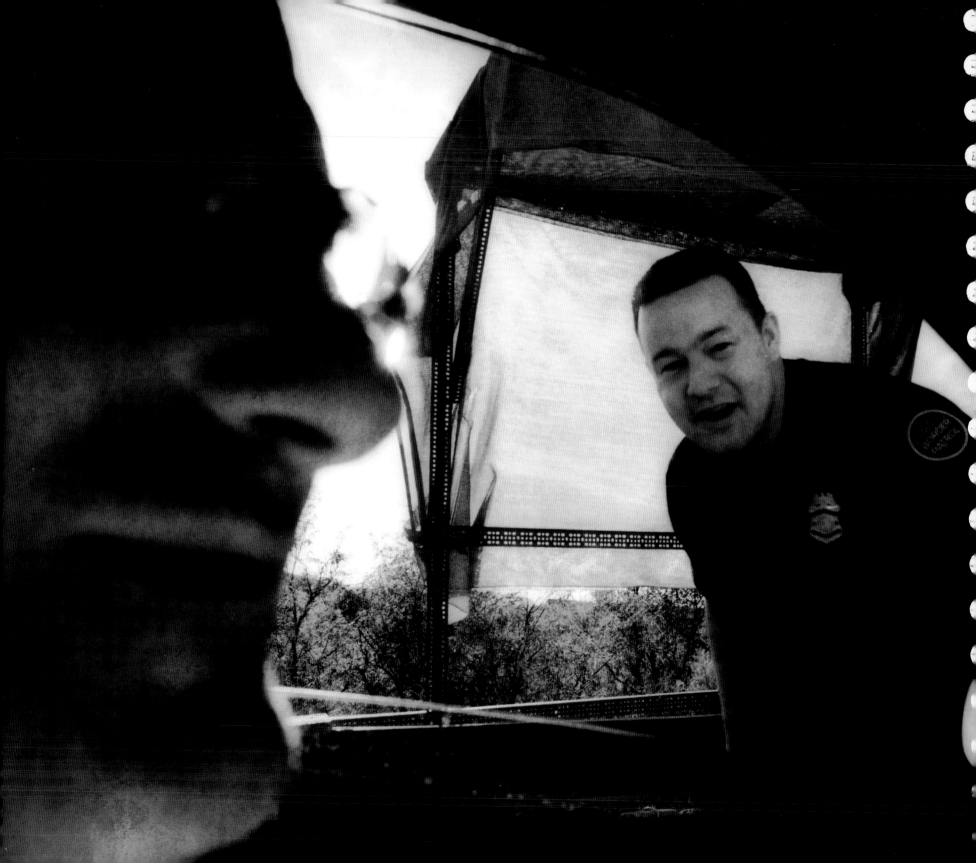

THE BORDER PATROL in the San Diego area has 2,000 agents patrolling the border. Each year they catch and return to Mexico approximately 500,000 illegal immigrants. Tijuana to San Diego is the hottest spot of all on the U.S.-Mexico border. Last month 15,000 acres on Otay Mountain, fifteen miles inland from the Pacific Ocean, burned up, probably the result of an illegal immigrant's campfire that got out of control. Each night hundreds of border runners risk heat exhaustion, fires, snakes, and thirst, not to mention bandits, to cross the 4,000-foot Otay Mountain. Pedro Acosta, a gardener apprehended by the Border Patrol on the mountain after journeying north from Sinaloa, Mexico, told a reporter, "We're very afraid of the journey. There are people who don't make it—and if you get lost in the mountains and can't find your way, you remain there." In the last two years, the Border Patrol has logged more than twenty immigrants' deaths in the region, most from exposure. It's a five- or six-mile trek across the mountain. Out of fear that border runners will be trapped and killed in summer fires, the U.S. Department of the Interior spends hundreds of thousands of dollars extinguishing blazes they normally would allow to burn out naturally. Also, the Bureau of Land Management is concerned that native Tecate cypress plants, which are protected as part of Otay Mountain's Wilderness Study Area, will be eradicated not only by wildfires but because the plants grow in the canyon beds where the illegals have created trails, trampling the plants, their feet grinding down the root systems. Even the local flora are victims of violence on the border.

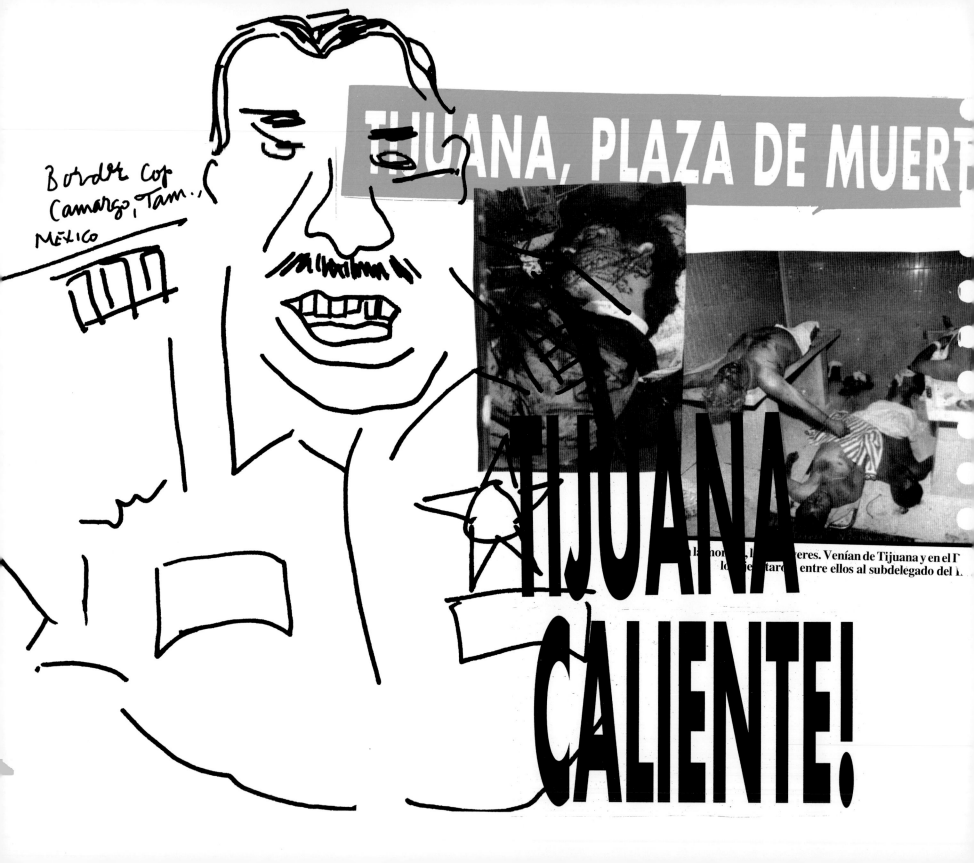

Border Cop
Camargo, Tam..
México

TIJUANA, PLAZA DE MUERT

TIJUANA
CALIENTE!

la noche, los ...eres. Venían de Tijuana y en el ...
los ...taron entre ellos al subdelegado del ...

NARCOGATILLEROS!

TO CELEBRATE the anniversary of Mexico's independence we went into the Fuzzyland Bar off the Avenida de la Revolucion and had a beer. As soon as we sat down at the bar we were set upon by four prostitutes, two of whom immediately pulled down their tops and showed us their tits. The other two insinuated themselves between barstools and rubbed our crotches, asking us if we wanted to go upstairs. The room was lit very dimly in dead red. We ordered Tecates for ourselves and the girls. It was the perfect way to celebrate the anniversary night of the Mexican Revolution. The Fuzzyland bar is a bi-sexual whorehouse, catering to both men and women. One thing about Mexico, there's virtually no subterfuge when it comes to sex—you want it, here it is.

At the request of Mexican officials, the Treasury Department's Bureau of Alcohol, Tobacco and Firearms will try to determine if nearly 4,300 guns recently confiscated in Mexico came from the United States, the department said. The Mexicans worry that guns smuggled from the United States could provide drug traffickers with more firepower than local authorities have.

The Monitor / Patrick Hamilton

"PACHANGA" FOLLOWER: Delta Area Constable Eduardo "Walo" ...zan stands in front of his black Crown Victoria in Elsa. His office and campaign style are reflective of the "pachange politics" that are at the h.. art of hte Valley system.

Nadaraján lleva en el pecho a su hermano gemelo que nunca nació

TROPICAL BEES

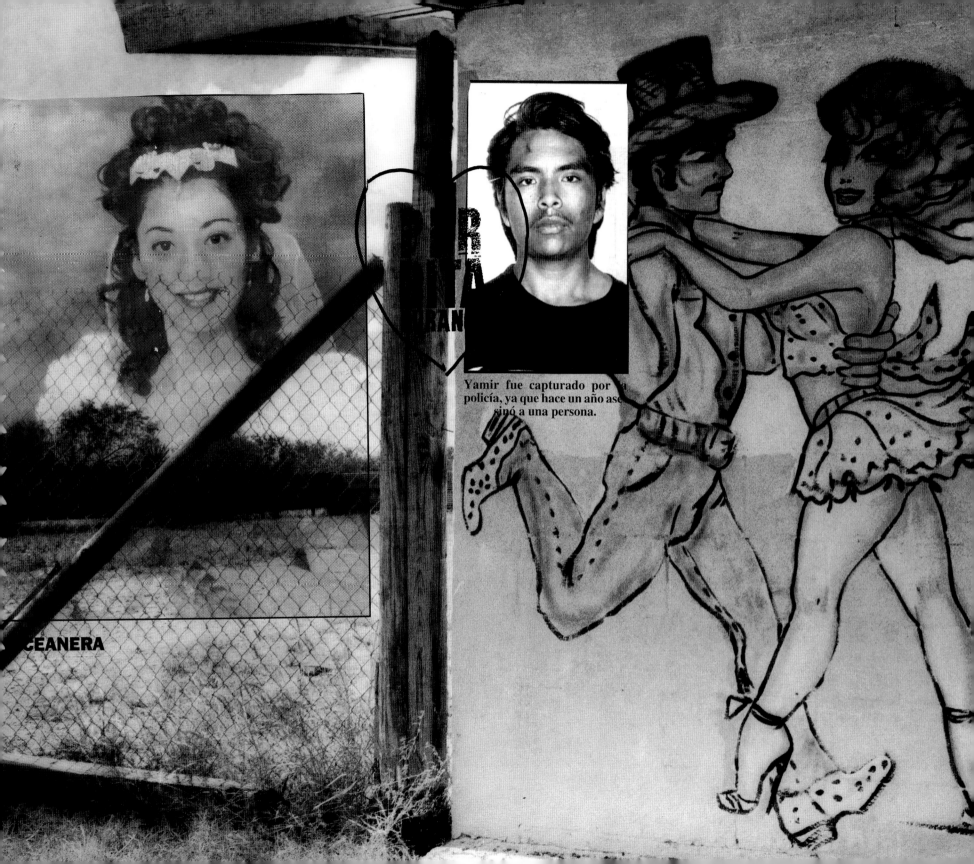

Yamir fue capturado por la policía, ya que hace un año asesinó a una persona.

CEANERA

reet, Sa

3 de za

ities para cuida

ANDIA - MÚSIC

Juan, a taxi driver in Tijuana, told me that the rebels in Chiapas are a joke. There can be no revolution in Mexico unless there is also a revolution in the United States."

DROVE OUT TEXAS HIGHWAY 4 to the end at Boca Chica and the Gulf of Mexico. Just south of Boca Chica was Boca del Rio, called Bagdad, which flourished as an international traders' paradise during the War Between the States and was destroyed by a hurricane after the war.

BEING AT BOCA CHICA and the end of the road reminded me of all the years my Uncle Buck and I went fishing from Ozona, Florida, at the end of Hillsborough Avenue in Tampa, near Oldsmar. We'd launch the boat there and cruise out from Tampa Bay into the gulf.

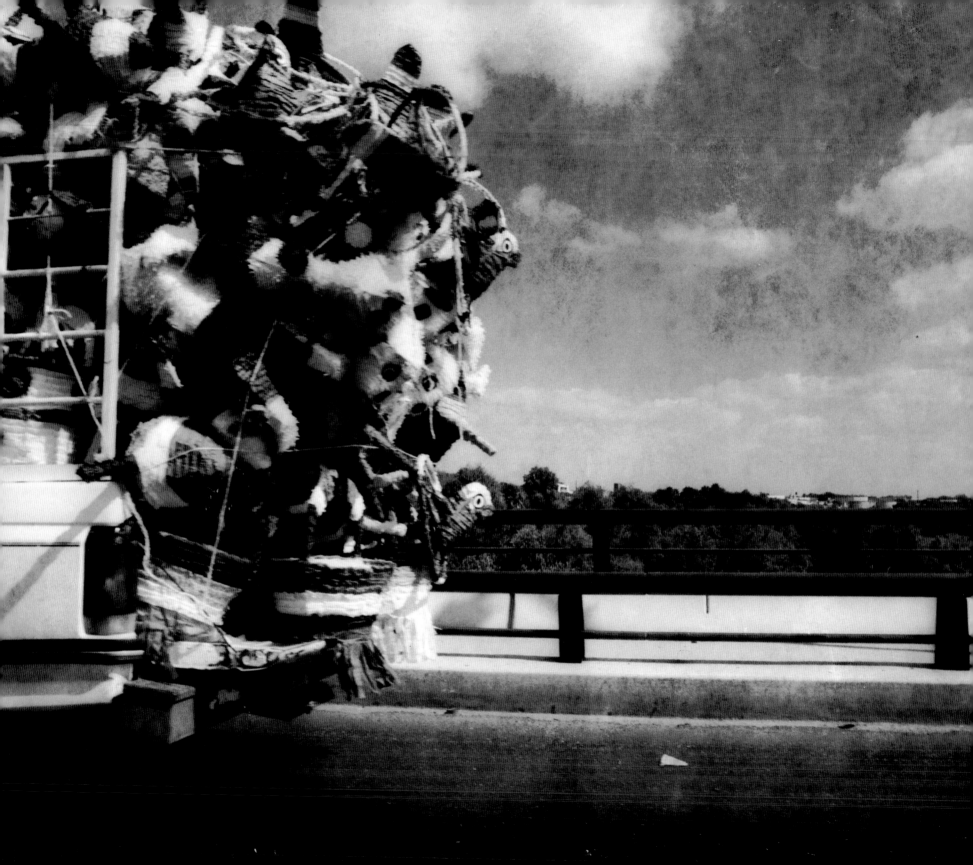

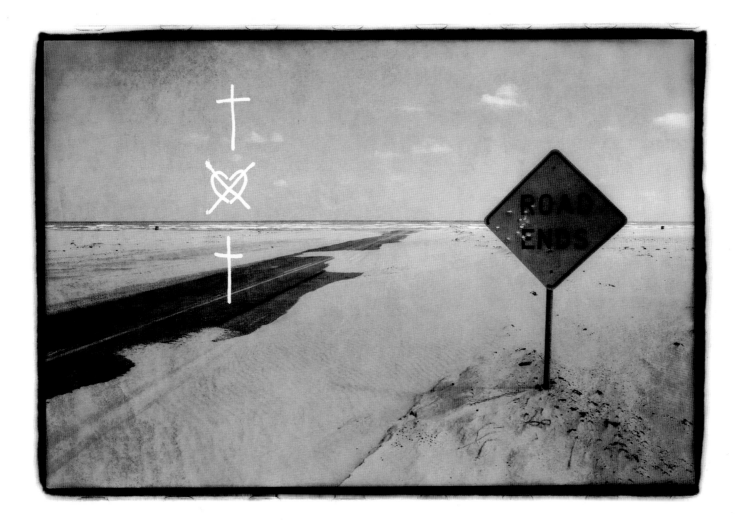

Calle

Mississi

ppi was

extremely

narrow. The buildings

leaned toward each

other, reducing the sky to a violet

stripe. He passed number forty-four

and slowed his pace. When he was in front of number fifty, he

stopped. Suddenly the street tilted, or he did. His hat fell off. He tried

to pick it up but could not reach that far. He saw the hat lying on the

sidewalk. Number fifty Calle Mississippi was his address, and he

moved toward the door. Then he remembered his hat. Leaning down

to pick it up, he suddenly saw nothing but black, and he collapsed on

top of his hat.

Thousands of blackbirds exploded out of the trees, and he recalled
what the new mother of the stolen boy, Omar Vargas, had said,
"When you see blackbirds In January in Mississippi, It's going to be
cold. If you see a robin, it's going to snow." The name of the place
was Flora. Now he was back home in Mexico City, on Calle Missis-
sippi. He rose slowly and got to his feet, holding his hat in his right
hand. He moved toward the door of number fifty

without any memory

of what

awaited him.

Bordertown

is a place to make money,

spectacles to

attract tourists,

a sopa picante with

a touch

of evil

Man knifed on Juarez

sidestreet,

stiff after

two days,

his stink

not even noticeable

or defined among the

general stench

by Club Colorada

A miniature Yolanda all

mouth and eyes

shimmering in

a doorway,

Bordertown is the city of spooks,

 of greedy ghosts

and unapproachable

 visions

Dirt streets of

 deep southwest,

pariah dogs groan

 in the fabulous dust

 and heat,

flies laying eggs

on chickens

 and hanging

 pigs

The only certainty is

 at the cemetaries, the

 only grip

on life to visit and

 revisit

the acknowledged dead

The living dead pay homage

 to each other's fate,

a place to

 finally meet

and be restful

Impossible to be at

 peace

in this crush,

 this pesthole

 life built

on the refuse of

 El Norte

Whores in the broken

 light like

 giant parrots,

birds ready

 to peck your eyes

and pick your pockets

 At the same time

 become dreamy

Aztec princesses muy sincero

 y las romanticas

 de sus suenos

The ramshackle countryside

 devours the border sun,

thin wind

 tickles scabrous brusn

as border patrol run down

 rats scurrying

from the rotten

 stinking sinking

 ship

 like pinatas falling

 off the back

 of a speeding

 truck

Here's where the road

 ends,

 in the ground or at water's edge—

 Boca Chica, the girl's

 mouth,

 the gates

 of hell

 or heaven

 swung

 wide,

 waiting to

 receive you,

 the same in death

 as in life,

 forever.

Map text (geographic labels):

San Diego · BAJA CALIF. · Mexicali · Yuma · ARIZONA · Phoenix · Mesa · Tucson · SONORA · Nogales · NEW M · Albuquerque · El Paso · Ciudad Juarez · Las Cruces · CHIHUAHUA · Chihuahua · Hidalgo del Parral · DU

DESC.	LOCATION
to mexico	Nogales, *Arizona*
border crossing	Nogales, *Sonora*
beggars & bridge	Nuevo Progreso, *Tamaulipas*
guy in the road	Ciudad Juarez, *Chihuahua*
rio grande north	Progreso, *Texas*
rio grande south	Nuevo Progreso, *Tamaulipas*
señora	Nuevo Laredo, *Tamaulipas*
tough boy	Nogales, *Sonora*
wrestlers	Ciudad Juarez, *Chihuahua*
bullfight	Boystown, Nuevo Laredo, *Tamaulipas*
rosted	Nuevo Progreso, *Tamaulipas*
old hombre	Laredo, *Texas*
touristas	Nuevo Laredo, *Tamaulipas*
bighead	Ciudad Díaz Ordaz, *Tamaulipas*
slumped boy	Nuevo Laredo, *Tamaulipas*
sea turtle	Nuevo Laredo, *Tamaulipas*
hallmark	Nogales, *Sonora*
greyhound	Nogales, *Arizona*
plastic jesus	Nogales, *Sonora*
stetsons	Laredo, *Texas*
skulls	Nogales, *Sonora*
royalty rock's	Ciudad Juarez, *Chihuahua*
man in a doorway	Ciudad Juarez, *Chihuahua*

IN COAYACAN it's a tradition to stick a turkey in a basket and dance beside it before sacrificing it. Afterwards, those in attendance smoke cigarettes and talk about the good old days, before fighting over who gets to drink the turkey's blood.

muerto soy	Ciudad Juarez, *Chihuahua*
waitin' for the bus	Nogales, *Sonora*
white hat/black hat	Nogales, *Sonora*
tiger girl	Laredo, *Texas*
crosswalk	Nogales, *Sonora*
dracula	Laredo, *Texas*
señorita	Laredo, *Texas*
reward	Agua Prieta, *Sonora*
batkid	Laredo, *Texas*
travis	Tijuana Baja, *California*
barriga	Nuevo Laredo, *Tamaulipas*
carne	Nuevo Laredo, *Tamaulipas*
insurance	Nuevo Laredo, *Tamaulipas*
stunt man	Tucson, *Arizona*
dog mask	Nuevo Laredo, *Tamaulipas*

DESC.	LOCATION
tunnel	Nuevo Laredo, *Tamaulipas*
accordion player	Nuevo Laredo, *Tamaulipas*
fuzzy lights	Tijuana, *Baja California*
streaptease	Tijuana, *Baja California*
newsstand	Tijuana, *Baja California*
el camarero	Boystown, Nuevo Laredo, *Tamaulipas*
bar star	Boystown, Nuevo Laredo, *Tamaulipas*
marlbo 5	Boystown, Nuevo Laredo, *Tamaulipas*
comic girl	Boystown, Nuevo Laredo, *Tamaulipas*
comic girl II	Boystown, Nuevo Laredo, *Tamaulipas*
A & J	Boystown, Nuevo Laredo, *Tamaulipas*
trucker mama	Boystown, Nuevo Laredo, *Tamaulipas*
puta's crib [triptych]	Boystown, Nuevo Laredo, *Tamaulipas*
mercy	Hwy 281 east of McAllen, *Texas*
road and rain	Hwy 83 north of Nogales, *Arizona*
dog crossing	Ciudad Juarez, *Chihuahua*
the edge of town [triptych]	Nuevo Progreso, *Tamaulipas*
sleeping dog	Nuevo Laredo, *Tamaulipas*
gravetender	Nuevo Laredo, *Tamaulipas*
jesus y mickey	Nogales, *Sonora*
boy in the road	Tijuana, *Baja California*
paint booth	Caseta, *Tamaulipas*
el mercado	Agua Prieta, *Sonora*
man looks right	Ciudad Juarez, *Chihuahua*
rural casa	Ciudad Diaz Ordaz, *Tamaulipas*
rural casa	Ciudad Diaz Ordaz, *Tamaulipas*
bag & car	Nogales, *Arizona*
border patrol	Hwy 19 north of Nogales, *Arizona*
border patrol	Hwy 19 north of Nogales, *Arizona*
wall dancers	Los Ebanos, *Texas*
easy rider	Brownsville, *Texas*
piñatas	Laredo, *Texas*
road ends	Boca Chica, *Texas*
suave hombre	Laredo, *Texas*
barry & david	Rio Grande, *Mexico-U.S. border*

1 2 3 4

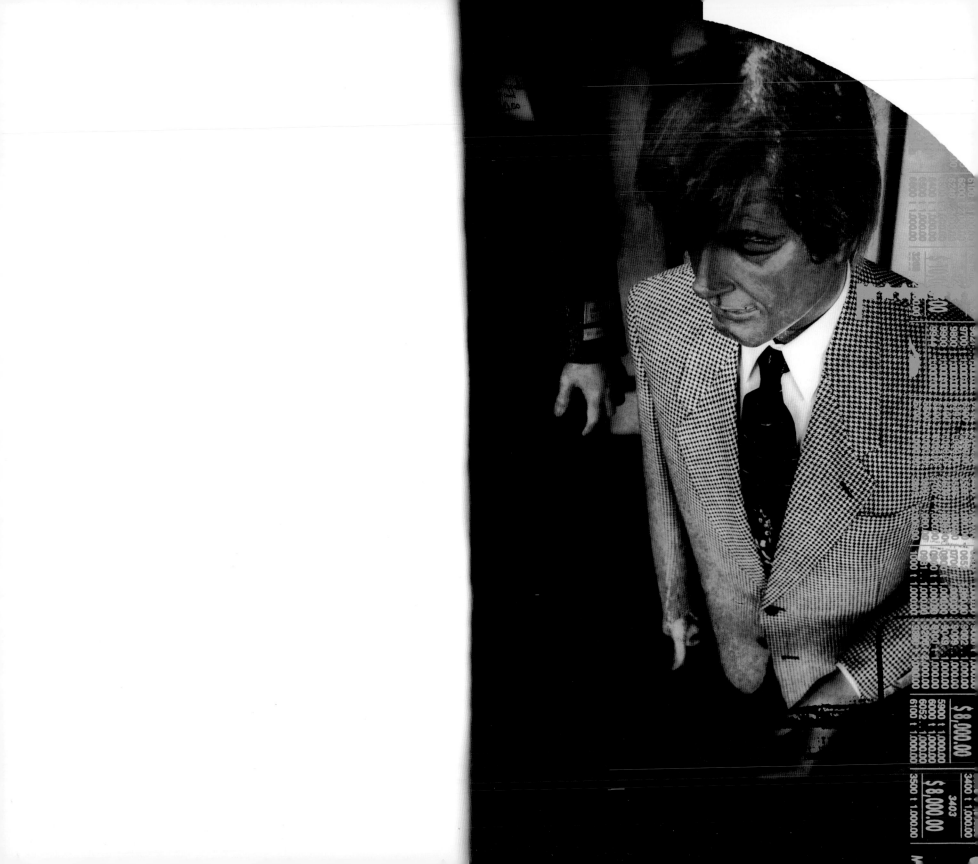

MIL PESOS

200

7455

$10,000.00

3199

$10,000.00

3200

$20,000.00

Por terminación a las 4 últimas cifras del Primer Premio.

Fue entrega-
do para su
venta en su
Serie "A" al
Expendio Lo-
cal No. 21 "Ba-
dillo Billetes"
acargodelaC.
Ma. Alejandra
Badillo Molp-
he, estableci-
do en la calle
de Monte de
Piedad No. 9
"C" Esq. 5 de
Mayo Centro.

$12,000.00

$4,000.00

7133

0059

$12,000.00

$6,000.00

5059

$12,000.00

2502

MIL PESOS

80

4544

$10,000.00

3200

$20,000.00

Por terminación a
las 4 últimas cifras
del Primer Premio.

$24,000.00

3201

$20,000.00

3200

Por terminación a
las 4 últimas cifras
del Primer Premio.

$20,000.00

$6,000.00

7717

$6,000.00

9293

$12,000.00

Prize series labels (large numerals)

Series	Prize
5565	$4,000.00
40 MIL PESOS	
200	
1455	$10,000.00
4877	3200 $10,000.00
200 MIL PESOS	
3199 $20,000.00	
0358	40 MIL PESOS
4544	80 MIL PESOS
8774	3201
2 MILLONES DE PESOS	
80 MILLONES DE PESOS	

Fue entregado para su venta en su Serie "A" al Expendio Local No. 21 "Badillo Billetes" a cargo de la C. Ma. Alejandra Badillo Molphe, establecido en la calle de Monte de Piedad No. 9 "C" Esq. 5 de Mayo Centro.

Por terminación a las 4 últimas cifras del Primer Premio.

Fue remitido para su venta.

Fue remitido para su venta en su Serie "A" a la Agencia Expendedora en Piedras Negras, Coah.

Fue remitido para su venta en su Serie "A" a la Agencia Expendedora en Tepic, Nay.

Fue remitido para su venta en su Serie "A" a la Agencia Expendedora en Cuernavaca, Mor.